CULT MUSICIANS

CULT MUSICIANS

50 Progressive Performers You Need to Know

ROBERT DIMERY

WHITE LION
PUBLISHING

CONTENTS

INTRODUCTION

So what exactly is a 'cult' musician?

As you'll discover while reading this book, that short word covers a broad spectrum of character, talent and legacy. A number of the artists featured in these pages had tragically short careers (Lili Boulanger, Syd Barrett), while the reputation of others rests on a spark of brilliance that swiftly expired, or on a slender body of work – sometimes as slim as just one album – that still retains its ability to inspire (J Dilla, Arthur Lee, Nick Drake, The Slits).

Some of our subjects enjoyed major commercial success at a very early stage in their career. Alex Chilton with The Box Tops, Scott Walker with The Walker Brothers and Brian Eno with Roxy Music all had hit singles and – in Walker's case – prompted hysterical levels of adoration from fans. But they turned their back on all of that to seek out new, strikingly different landscapes that must have appeared alien to their original followers. What would the teenager who bought The Walkers' 1966 UK no.1 'The Sun Ain't Gonna Shine Any More' make of Scott's 1978 track 'The Electrician', set in a Latin American torture cell?

Bobbie Gentry, Captain Beefheart and Delia Derbyshire had long careers without ever fully achieving the recognition or success that their gifts warranted. Plenty of these artists were so richly endowed with talent and imagination that they were simply too prolific, changed tack too many times, or ventured into territories too strange and unfamiliar to win a steady audience and mainstream acceptance (Kool Keith, Brigitte Fontaine and Mark Hollis). And of course, relentless productivity can all too easily result in quality control going out of the window...

Others had to struggle just to escape from the shadow of a partner's profile. And,

yes, they were all women. Yoko Ono was (wrongly) vilified for her part in allegedly breaking up the Greatest Band in the World – never mind that she was already an established artist by the time she met John Lennon. And in the 1970s, her music regularly explored far riskier territories than that of her husband. Marianne Faithfull went the long and hard way round to shuck off her image as a pure-voiced 1960s pin-up and Mick Jagger's girlfriend, before establishing herself as a worldly wise chanteuse of depth and intelligence.

During the 1990s, I went to a talk given by the author John Fowles. Asked about any advice for aspiring writers in the audience, he replied that the first thing you needed to do was kill your parents. Or, to cut to the heart of his metaphor: don't let anyone get between you and your art – always write for yourself, never for others. And if we're looking for threads that might connect the tapestry of singular talent in *Cult Musicians*,

then absolute devotion to your music – whether or not anyone is listening – is a prime one.

Mark E Smith highlighted the surreal in the everyday, with lyrics simultaneously arresting and dumbfounding. And no one – least of all the other members of The Fall (of which there were around sixty-six over the years, give or take a guitarist or two) – was allowed to get in the way. For decades, Moondog played his own compositions, on instruments he'd designed himself, on the streets of New York, entirely on his own terms; he let the world come to him. And Sun Ra's orbit was also famously irregular, but it led him to redefine the course of jazz (and rock), and like Moondog, he was under no illusions as to the way he was generally perceived or the sacrifices he would have to make to fulfil his aims.

Frank Zappa delighted in scatological or sexually provocative lyrics, but he was also a hugely prolific and fiercely smart composer,

working in the fields of modern classical music, rock, jazz and all points in between, and respected by the Czech president Václav Havel – if not the US government – for his uncompromising art. It would be all too easy to write off reggae producer Lee 'Scratch' Perry as a cartoon eccentric, were it not for his stream of game-changing recordings during his 1970s imperial phase. And Serge Gainsbourg may have offended large sections of French society with his uncensored comments and increasingly out-of-bounds behaviour, but his clear-eyed honesty about human foibles and frailties, coupled with his exceptional songcraft, transcended the tabloid myth.

It follows that most, if not all of the artists in this book are supremely individualistic – iconoclastic, even. You might say that each of them has evolved a genre of their own, and in the case of the most vibrantly innovative artists, a whole string of genres.

For many of our subjects, conventional Western rock music just doesn't cut it when it comes to mapping out human experience. Sun Ra's 1974 release *Space Is the Place* (which accompanied the Afrofuturist movie of the same name) set the controls for Way Out There – and artists as diverse as Delia Derbyshire, Eno and Syd Barrett were all on board. In common with the great John Cage – a pivotal influence on Eno and Ryuichi Sakamoto – many of the artists in these pages asked what 'music' was anyway, and came up with ways to redefine it. Likewise, the search for alternative philosophies and ways of being saw Cage (again) embrace Buddhism, while its concepts of fluidity and lack of resolution – existence as flow, in other words – certainly impacted on the work of cello-playing avant-garde disco experimentalist Arthur Russell.

Sometimes these non-conformists appeared uniquely fully formed from the off, marking a clean break from the past. But all of them (even Ra, or Beefheart for that matter) started somewhere, building their fantastic sound palaces on solid foundations – jazz and blues, in the case of those two maverick visionaries. Everything comes from something, however roundabout the route. The repetition and 'floating' quality of many of the works by late-19th-century composer Erik Satie, and his concept of 'furniture music' (using sounds that influence the mood in a room without drawing attention to themselves), re-emerges in Cage's playful, outside-the-box innovations. ('It's not a question of Satie's relevance,' Cage insisted. 'He's indispensable.')

Satie and Cage, in turn, held great sway over Eno in his development of 'ambient music' in the 1970s. And it was Cage's emphasis on rejecting ingrown habits (which might include a tendency

to repeat hackneyed chord sequences, playing styles, lyrics, attitudes or prejudices) that led to Eno's 'Oblique Strategies' cards. Developed with Peter Schmidt, each one bears an apparently random instruction intended to encourage an individual to try something new.

Sadly, another recurring element among our chosen fifty is fragility – 'a skin too few', to use a phrase often applied to Nick Drake but which also holds for Sandy Denny, who had a bewildering lack of belief in her own talent. Syd Barrett is regularly dismissed as an 'acid casualty', but that easy term ignores his mental instability and the pressures he was under as the prime songwriter and charismatic focus of a young band hungry for success.

So why have we included well-known and relatively successful artists such as Édith Piaf, Björk, Nick Cave and Patti Smith in this survey? Likewise, Sakamoto is hardly a penniless garret-haunter, having penned a string of soundtracks to major movies, one of which (*The Last Emperor*) earned him an Oscar. PJ Harvey has two Mercury Prizes to her name, the only artist to have achieved that feat to date. By what stretch of the imagination do they qualify as 'cult'? I'd argue that, taken as a whole, their public recognition has come without artistic compromise. For all her international fame, Piaf endured plenty of suffering, reflected that in her music and remained a hero for society's outsiders and victims. Björk has instinctively engineered radical changes in musical direction, never letting anything but her own wild muse dictate the course of her career. And Sakamoto's movie scores are heard by millions, but they're complemented by avant-garde excursions into electronica and solo piano works with a far smaller audience.

The work of these fifty artists can't easily be pigeonholed. It transcends benchmarks such as chart places or royalties, tweets or YouTube clicks, because ultimately it cuts to the core of what we're all about as people: the ecstasy and melancholy, weakness and strength, humour and terror, the awkwardness and maddening inconsistencies of being human and being alive. In short, whatever the size of their media profiles or bank accounts, these musicians have produced work that resonates with the rest of us in a way that mainstream music of the day can't – and often continues to do so long after their day.

'I just wanted to do my own thing,' Moondog once explained, 'and no matter how much it cost me in terms of my career, I did it.' That pretty much sums up a cult artist – or indeed any artist worthy of the name.

LAURIE ANDERSON (1947)

—— MULTIMEDIA MAVERICK

The spoken word is at the heart of Anderson's art, dominating her best-known track, the mesmerizing 'O Superman', which gave her a surprise UK no.2 in 1981. But that unsettling song offers only a glimpse of this artist's diversity.

Anderson moved from Chicago to New York in the late 1960s. While studying sculpture, she learned her craft as a performance artist and went on to mix with the likes of Philip Glass and Arthur Russell in the downtown arts scene. She is a joyfully cross-platform artist, whose musical inventions included a tape-bow violin (with a playback head on the bridge and magnetic tape replacing the horsehair bow strings) and the 'talking stick' (a 6-foot MIDI device that uses granular synthesis to reconfigure and play back sound). The talking stick would be used (harpoon-like) to trigger sounds on a computer in her 2000 techno-opera staging of *Songs and Stories From Moby Dick*. She was also a pioneer of voice-filtering to lower her vocal register, or in her words, 'audio drag'. Technology, and its impact on our culture and life, has always been a core theme of her work, and remains so today.

'O Superman' appeared on Anderson's first LP, *Big Science* (1982), along with other excerpts from the large-scale *United States*, an eight-hour performance work featuring vignettes of her homeland. The latter appeared as the five-album set *United States Live* in 1984, the same year that her *Mister Heartbreak* set was released; Peter Gabriel, Bill Laswell and writer William Burroughs all featured, and Burrough's mordant humour was one of her enduring influences.

As a heterogeneous artist, her music-making has to compete for space with her tours and large-scale multimedia projects, such as the concert film *Home of the Brave* (1986). Many of her 21st-century recordings have been a reflection of loss and grieving. *Live in New York* (2002) was recorded shortly after the World Trade Center attacks, while *Heart of a Dog* (2015) reflects on the loss of her beloved pet Lolabelle, her childhood traumas, our dream lives and 9/11. Fittingly, the final track, 'Turning Time Around', was written and performed by her late husband Lou Reed. The Buddhist text *The Tibetan Book of the Dead* was a core influence for this singular artist, who has always paired artistic adventurism with a solid grasp on universal values. 'It's all about what I do as an artist,' she reflected in 2016. 'How to be aware. That's it.' The human condition seen through an avant-garde prism.

APHEX TWIN (1971)

—— DEVILISHLY GOOD TECHNO TITAN

Polymorphous and prolific, the man born Richard D. James is about as easy to pin down as mercury. He has performed from within a Wendy house, wearing a mask of his own face, behind teddy-bear-suited dancers. And at London's Disobey club in 1994, he played sanding discs. Very loudly. In interviews, he said sleep was wasted time and talked about lucidly dreaming tracks that he would record once he'd woken up.

His first release as Aphex Twin, 'Analogue Bubblebath' (1991), paired breathy chords with acidy squelches, while abrasive club hit 'Digeridoo' featured a breakneck 160 bpm tempo. The first album, compilation *Selected Ambient Works 85–92*, showcased an Eno-like electronic minimalism (alongside some squelchy acid techno) and has become an ambient music landmark. His predisposition towards experiment and innovation (he'd reportedly reconfigured cheap synths since his youth) rapidly made him an in-demand remixer.

I Care Because You Do (1995) and *Richard D. James Album* (1996) incorporated harder beats but also string arrangements and hints of jazz; Philip Glass orchestrated 'Icct Hedral' for the 1995 EP *Donkey Rhubarb*. By now, his experiments in sound were taking him into the realms of avant-garde luminaries such as Karlheinz Stockhausen, Iannis Xenakis and György Ligeti (a declared influence) and saw him dubbed a pioneer of so-called intelligent techno.

The *Come to Daddy* EP (1997) marked a return to drum 'n' bass madness. Chris Cunningham's controversial video for the track (originally a 'joke death metal jingle', according to James) sees the birth of a demonic spirit on a council estate and a gang of vandalistic young girls sporting Aphex Twin masks. Meanwhile, for 'Windowlicker' (1999) – all slippery beats and weird electronic interjections – Cunningham offered a surreal take on gangsta hip-hop videos of the time, James rolling in a pimped-out stretch limo with two lovelies whose faces morph into his own manically grinning likeness.

Live gigs aside, James kept a low profile, aside from a series of 12-inch singles titled *Analord* in 2005 (credited to AFX) and album *Rushup Edge* as The Tuss, although his involvement was only confirmed years later – further augmenting the aura of mystery around him, of course. The beguiling scope of his interests was reflected in a 2011 live homage to Krzysztof Penderecki and remix of the latter's 'Threnody to the Victims of Hiroshima'. In August 2014, a blimp bearing the name 'Aphex' rose above London, heralding James's return for the (Grammy-winning) *Syro*. Another enigmatic marketing campaign (his logo appeared in a selection of major cities) accompanied the release of the *Collapse* EP in 2018.

Mixing music while preserving the myth, Aphex Twin continues to keep us guessing.

" I JUST LIKE MUSIC THAT SOUNDS EVIL OR EERIE. "

SYD BARRETT (1946-2006)

—— PSYCHEDELIC PIONEER

In a brief but scintillating creative flush in the late 1960s, Roger Keith 'Syd' Barrett helped redefine British pop.

As a child growing up in a middle-class household in Cambridge, he favoured art and writing over music. But by the early 1960s his ears were alerted first to The Beatles and then The Rolling Stones and Bob Dylan. After enrolling at Camberwell School of Arts in London in 1964, he joined the fledgling Pink Floyd.

By 1966, the band (their name a portmanteau coined by Barrett after two bluesmen – Pink Anderson and Floyd Council) were morphing from an R&B outfit into something looser and more daring. Their sets featured extended improvisations and primitive oil-slide lighting. Barrett's songwriting was blossoming: concise, off-kilter gems such as 'Matilda Mother' and 'Lucifer Sam' married pop nous and musical invention, while 'The Gnome' and 'The Scarecrow' dipped into childhood fancies. There was a distinctly English quality to his subjects, something underlined by his precise enunciation.

As house band at Tottenham Court Road's UFO club, Pink Floyd became darlings of London's underground scene. The charismatic Syd was the linchpin, a curly-haired psych prince coaxing otherworldly sounds from his guitar. Barrett gave the Floyd their first hits with 'Arnold Layne' (a breezy tale of transvestitism) and the sublime 'See Emily Play'. His finest hour remains their debut album, *The Piper at the Gates of Dawn* (the title drawn from Kenneth Grahame's classic children's novel *The Wind in the Willows*), largely composed by him. Sci-fi imagery and sounds run through 'Astronomy Domine' and the mighty 'Interstellar Overdrive' – nine minutes plus of freeform invention bookended by a ferocious, savage riff.

Yet as 1967 drew on, Barrett's behaviour began to deteriorate alarmingly. Increasingly withdrawn and unreachable, he'd play the same note throughout a set – or slowly detune his guitar. Heavy LSD consumption certainly played its part, but the pressure of being the band's golden goose clearly got to him too. By early 1968, the band had drafted in David Gilmour, hoping to encourage Barrett to concentrate on his songwriting. But the challenges proved insurmountable, and one night, en route to a gig, they simply chose not to pick Syd up.

Two solo albums – *The Madcap Laughs* and *Barrett* – followed, in which moments of luminous beauty ('Golden Hair', 'Terrapin', 'Late Night') were offset by other, disconcertingly fragile performances. His sporadic live performances dwindled. By the early 1980s, Syd was once more living with his mother in Cambridge, and had abandoned music for art.

That fleeting career left a long and permanant legacy, though. His defiantly English delivery and quirky songcraft has inspired a raft of artists, not least David Bowie and Blur, while his distinctive, choppy guitar style anticipated punk and post-punk (both Sex Pistols and The Damned attempted to enrol him as their producer). Barrett's elfin appearance – all messy hair and eyeliner – clearly rubbed off on Marc Bolan and The Cure's Robert Smith. And, of course, his shadow never left Pink Floyd – *The Wall* (1979) draws on aspects of his erratic behaviour. Most poignant of all is their 1975 tribute to him, 'Shine On You Crazy Diamond'.

KAT BJELLAND (1963)

—— ORIGINAL RIOT GRRRL

As lead singer with Babes in Toyland, Bjelland produced a wilfully uncompromising body of work that inspired a host of other artists, not least the so-called riot grrrl bands. In 2012, Bikini Kill's Kathleen Hanna recalled being blown away by BiT's live intensity: 'I'd never heard anything like it and haven't heard anything since like it… the combination of the femininity with the strength in the music in saying that femininity and strength weren't the opposite of each other.'

The band formed in Minneapolis in 1987, with Bjelland joined by drummer Lori Barbero and bassist Michelle Leon; Courtney Love, who had played with Bjelland in bands while the two were in Portland, occasionally rehearsed with them (some early Hole songs share lyrics with BiT tracks). BiT's early sound was abrasive and amateurish, but Bjelland saw Barbero and Leon's lack of musicianship as a way of unlocking their instinct and imagination. She herself developed into a sometimes-terrifying vocalist, possessing an unnerving scream ('I just push myself into things where I think I can't reach notes and stuff', she observed in 1992). A potent guitarist too, she incorporated elements of psychobilly, metal and 1960s garage fuzz into a gritty mash-up.

Debut album *Spanking Machine* (1990) was a passionate and unsettling collection, championed by British DJ John Peel and Sonic Youth's Thurston Moore, who invited BiT on their European tour (Bjelland's 'kinderwhore' look –little-girl dresses, barrettes and bows in her hair – would be widely copied). The anger became more focused on 1992's commercial success *Fontanelle*, featuring standouts 'Handsome and Gretel' and 'Bruise Violet'. Their profile peaked with the 1993 Lollapalooza tour, but *Nemesisters* (1995) was less well received; changing line-ups and hiatuses hampered their momentum, and they finally split in 2001. With Glen Mattson, her husband of the time, Bjelland went on to form Katastrophy Wife, whose output include the well-received *All Kneel* (2004).

Much of Bjelland's primal aggression stemmed from her own personal traumas and mental unsteadiness. She claimed to have been abused by her stepmother as a child, while Kurt Cobain's suicide in 1994 triggered a breakdown; heroin addiction further compromised her. In 2007, she revealed she had been diagnosed with a schizoaffective disorder.

At a time when stereotypes and inherent sexism in the rock 'n' roll industry offered few inspirational female figures, Kat Bjelland provided a vibrant fuck-you alternative. Sleater-Kinney, Bikini Kill and Jack Off Jill have paid homage to her uncompromising and relentless artistry, but her impact on her audience was lasting too, as reflected in the warmth with which the 2015 Babes in Toyland reunion was welcomed.

BJÖRK (1965)

—— ICELANDIC COOL

Few artists have initiated as many sea changes in their oeuvre as Iceland's Björk Guðmundsdóttir. She was a recording artist at the age of eleven, when her album of pop covers became a hit in her native country. But her first taste of international success came with avant-garde indie outfit The Sugarcubes, whose debut album *Life's Too Good* (1988) – featuring 'Birthday', the larger world's first experience of her all-or-nothing vocals – was a transatlantic hit. There's something almost childlike about that voice and Björk's restless enthusiasm for new projects and sounds, although that's not to undermine her shrewd career choices and focused work ethic.

Following the band's 1992 split, Björk wholeheartedly embraced dance culture. Preceded by the Nellee Hooper-produced 'Human Behaviour', her first solo outing *Debut* (1993) enjoyed immediate success. Poppy and superbly dancefloor-friendly,

it gave her a UK Top 3 placing, spawned a string of hit singles and became *NME*'s album of the year. Equally impressive was 'Play Dead', a majestic collaboration with Bond composer David Arnold.

Second album *Post* (1995) was an even bigger hit, although more experimental, highlighted by the menacing 'Army of Me' but also the big-band tune 'It's Oh So Quiet'. A cover of a Betty Hutton B-side (Björk's 1990 album *Gling-Gló* – made when she was still a Sugarcube – had showcased her interest in swing), it climbed to no.4 in the UK, her highest chart placing there to date. The experimental *Homogenic* (1997) was a more serious, less extrovert affair; the pressures of her increased fame (she was sent a letter bomb in 1996) was beginning to rattle her. Perhaps that explains the hiatus that lasted into the new millennium, when she re-emerged for an acclaimed performance in Lars Von Trier's controversial

movie *Dancer in the Dark* (2000); although the experience proved exhausting, she picked up a Best Actress award at Cannes for the role of Selma. The delicate *Vespertine* (2001) saw a marked sonic shift, dialling down the intensity to a whisper, with beats by electronic duo Matmos sampled from sources such as a shuffled deck of cards and ice cracking. *Medúlla* (2004), by contrast, was almost completely a cappella.

One of Björk's strengths has always been her choice of collaborators, and for her next outing, the more expansively uplifting *Volta* (2007), her recruits included Timbaland, Toumani Diabaté and a female Icelandic choir. She broke radical new ground with the multimedia project *Biophilia* (2011), an album exploring relationships between technology, music and the natural world, accompanied by apps that explored musicology. 'Ambitious' doesn't begin to describe it. The project picked up a Grammy for Best Recording Package and became the first app acquired by New York's Museum of Modern Art (MoMA was to host a Björk retrospective four years later). But her next outing, *Vulnicura* (2015), shifted from the global to the deeply personal, a bleak but beautiful break-up album reflecting on her split with long-time partner Matthew Barney.

Match Björk's sonic adventurousness to her constantly changing image and you have a pop star whose scope and productivity puts most others to shame.

" I DO TRY TO LEARN AT LEAST ONE THING ON EVERY ALBUM, TO REACH OUT IN TERMS OF SOFTWARE OR GROWING IN MY ARRANGEMENTS, OR I PROBABLY TEND TO WRITE HARDER AND HARDER MELODIES FOR ME TO SING. I BECOME MY OWN TEACHER. "

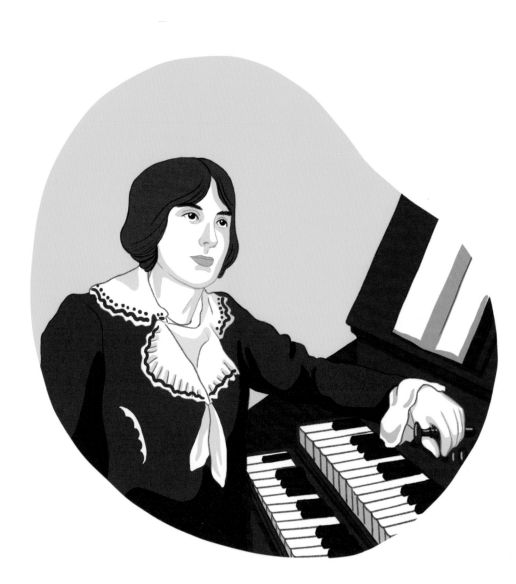

LILI BOULANGER (1893-1918)

—— IMPRESSIONIST PRODIGY

Lili Boulanger combated a lifetime of chronic ill health to produce a rich body of work, one that should have been the foundation of a major artistic reputation.

A near-fatal bout of bronchial pneumonia as an infant permanently compromised Lili's health. Knowing that her life would be curtailed, she worked with extraordinary focus to achieve her goals. As a teenager, she committed herself to music, mastering fugue, counterpoint and harmony. She studied at the Paris Conservatoire with the aim of winning the coveted Prix de Rome, which had eluded her sister, Nadia; the latter, later a world-famous composition teacher, abandoned her own ambitions to tutor her sister. In 1913, Lili became the first woman to win the Prix with her brooding dramatic cantata *Faust et Hélène*. A remarkable work for full orchestra, flecked with Wagnerian chromaticism and hints of Debussy, it satisfied all the academic criteria required of entrants. The prize secured, thereafter Lili began to expand the scope and ambition of her compositions, not least in the use of modes and unresolved chords.

Her mature, mostly vocal compositions display masterful sophistication, imbued with deep sensuality and melancholy. (Her father's death, when she was just six, affected her deeply and resonates in the themes of anguish and loss in her work.) Broadly impressionistic, they feature lush harmonies and otherworldly orchestrations,

bearing the influence of Gabriel Fauré (a family friend who also taught her) and Debussy without ever compromising her own distinct voice. Moreover, they engage with a rich and full emotional palette – witness the pairing of the darkly dramatic *D'un soir triste* with its playful partner *D'un matin de printemps*. And unlike many female composers of the time, including Clara Schumann and Fanny Mendelssohn, she received her due recognition while she was still alive.

Lili's Catholic faith imbues her three psalm settings for chorus and orchestra with a fervent intensity. Psalm 24 has a feeling of wondrous joy, the modal harmonies adding a primitive, ancient quality. Her setting of Psalm 130 (aka 'De Profondis'/'Du fond de l'abîme') possesses a sense of mystery fitting for a mystic vision of God's presence. Meanwhile, the thirteen-part song cycle *Clairières dans le ciel* (Reflections on a love lost) bears the influence of her sometime mentor Fauré, not least in placing equal importance on pianist and singer, but also showcases her own elegant setting of the poignant text.

Lili worked hard – completing some fifty compositions in all – and until the very end. On her deathbed, aged only twenty-five, she dictated her final piece – a setting of the *Pie Jesu* – to Nadia, who was to preserve and champion Lili's legacy for the rest of her own life.

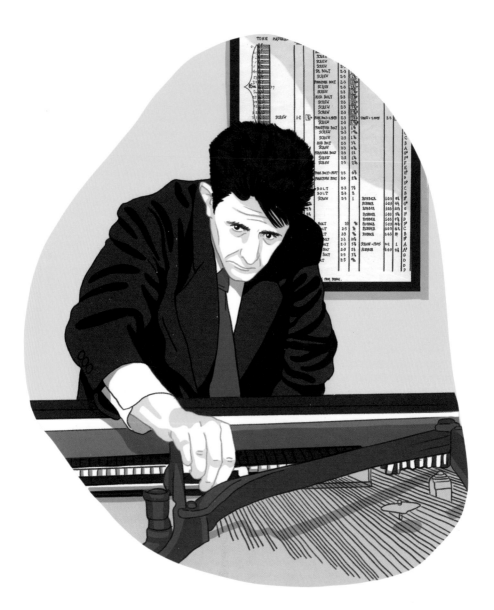

JOHN CAGE (1912-1992)

—— THE MUSIC OF SILENCE

John Cage helped to redefine our idea of what sound is. His studies under arch-serialist Arnold Schoenberg in the 1930s taught Cage to question what constitutes music, and as early as 1937 his lecture 'The Future of Music (Credo)' foretold the development of electronic sound, 'which will make available for musical purposes any and all sounds that can be heard'. Electronica pioneer Louis Barron said of working with Cage, 'you realize that you don't have to be restricted by the traditions, or the so-called laws, of music'.

He adored percussion – particularly Javanese gamelan – and constructed instruments made from automobile hubcaps, spring coils and brake drums. That passion also led him to create the first 'prepared piano' by inserting household objects between the strings of a piano. Some of the pieces he composed for it have a percussive violence to them; others possess a Satie-esque unworldliness.

An encounter with Surrealist icon Marcel Duchamp in 1942 proved highly significant: some thirty years earlier, Duchamp had written about composing by using chance as a technique, an idea that dovetailed with Cage's own lines of thought. His *Imaginary Landscape No.4* (1951) provided instructions for moving the knobs on a dozen radios; the resulting sounds were dependent on whatever was being broadcast, resulting in a unique performance every time. He also referred to the *I Ching* – the Chinese 'Book of Changes' – when composing *Music of Changes* (1951), rolling dice to decide musical directions. Cage's graphic scores were ambiguous, allowing performers increased creative input. In the 1970s, this conceptual jump fed directly into the ambient music of Brian Eno, who would set several tape loops running and let them 'compose' a piece.

Cage's use of silence to allow outside, 'found' sounds into a composition was not lost on Eno either. The simplicity and brilliance of the idea behind 4' 33" (1952) – as well as its notoriety – made Cage something of a whipping boy for all avant-garde composers. A performer sat at a piano, raised the lid but did nothing more except close it as each 'movement' ended. There was an element of Dadaist absurdity in it, and a humour perhaps related to Cage's Buddhist beliefs (which also influenced his interest in composing using random events: free from the artist's control, they broke with the tradition of music as self-expression). But it also made the provocative claim that the 'music' was whatever the audience heard in that time – from traffic noise outside the venue to their own heartbeats – alerting them to 'wake up to the very life we're living', in Cage's own words.

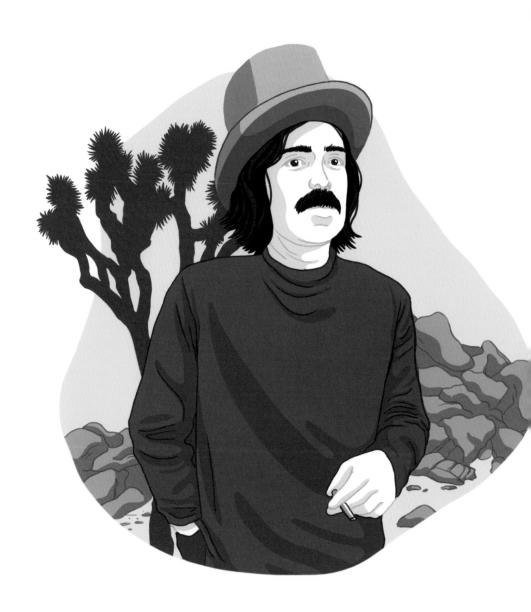

CAPTAIN BEEFHEART (1941-2010)

—— THE OUTSIDER'S OUTSIDER

Countless musicians have taken the blues and run with it. Don Van Vliet – better known as his stage name Captain Beefheart – ran further than most, and in a very different direction.

A talented artist in his youth, he went on to befriend Frank Zappa at high school, and their resulting love–hate relationship saw Zappa enlist him to sing on some early 1960s recordings, under the name The Soots. The following year, Van Vliet was singing with an early version of the Muddy Waters/Howlin' Wolf-influenced Captain Beefheart and His Magic Band. In 1967, with a young Ry Cooder on guitar, they made the terrific *Safe as Milk*. Weird but accessible, the tightly executed set paired the Captain's weathered rasp with hummable riffs.

The psych-blues *Strictly Personal* (1968) had some dazzling highlights, but double album *Trout Mask Replica* (1969) is his defining moment. Born from months of fractious rehearsals, and ringmaster Beefheart's dictatorial presence and mind games, it was an unprecedented achievement, melding complex rhythms, avant-gardism, free jazz, blues, rock and more. Guitarist Zoot Horn Rollo's description – 'anti-music sound sculptures' – is as good as any. Beefheart's jaw-dropping howl (he had a range of four-and-a-half octaves) delivered his surreal, allusive lyrics; one-time Magic Band member Gary Lucas praised them as 'Joycean'. Despite the painful gestation, its liberating ethos has proved inspiring to

countless artists, including John Lydon and the punk/post-punk movement, Tom Waits and PJ Harvey. Harvey herself befriended Beefheart in later life and regarded him as an artistic benchmark.

The album flopped Stateside at the time, but reached no.21 in the UK. Seeking a little commercial success after the excellent but similarly neglected *Lick My Decals Off, Baby*, a UK no.20 in 1970, Beefheart tamed his spikes of genius for a smoother soft-rock approach – although those albums barely charted either. It wasn't until 1978's *Shiny Beast (Bat Chain Puller)* that he gave his instincts free rein again.

This extraordinary artist indulged in a wealth of myth-making during his career, possibly not unrelated to his appetite for LSD. Perhaps Beefheart's iconoclastic sensibilities stemmed from his lifelong love of art. He'd won prizes for his sculptures as a child, and after he abandoned music in the 1980s to live in the Mojave Desert, he became an admired painter, broadly aligned to abstract expressionism and primitivism. (His declining health – it emerged that he had multiple sclerosis – may have been another factor in his retirement.)

Beefheart's most remarkable records stem from his determination to abandon familiar habits; he composed much of *Trout Mask Replica* on piano – an instrument he couldn't play. That way, of course, lies boldness and originality.

NICK CAVE (1957)

—— KING INK

The role of thoughtful elder rock statesman seemed an unlikely fit when Nick Cave first stormed the London music scene in the early 1980s with Australia's post-punk outfit The Birthday Party. Their Götterdämmerung-intense live sets, with Cave declaiming like a preacher gone wrong, singled them out, but prolific drug use and internal animosities led to a split in 1983.

Thereafter, Cave honed that scattershot intensity. His debut LP with The Bad Seeds, *From Her to Eternity* (1984), still clattered with gutbucket blues, but his voice and lyrics had greater room to breathe. Those first few albums were signposts for the road ahead: primal rock, Old Testament hellfire and the Southern Gothic myth (typified by the work of William Faulkner and Flannery O'Connor). He was to stake out that territory further with his first novel, *And the Ass Saw the Angel* (1989), written in Berlin, and with the movie score for *The Assassination of Jesse James by the Coward Robert Ford* (2007),

a collaboration with Bad Seed Warren Ellis. Cave had earlier explored the form of the Western in 2005's *The Proposition* (set in the Australian outback of the 1880s), for which he provided both soundtrack (with Ellis) and screenplay. Earlier still, *Murder Ballads* (1996) had paired traditional and original tales of homicide in the American West.

If his earliest oeuvre came decked in the red of sex and blood and the Bible black of revenge and death, covers set *Kicking Against the Pricks* (1986) saw Cave and the Bad Seeds expand their remit, finding new life in pop staples such as 'The Carnival Is Over'. Two years later, he showed his craftsmanship with 'The Mercy Seat', a stunning farewell from the perspective of a prisoner in the electric chair, with not a word wasted. (Johnny Cash, a deep influence on Cave, covered it on his *American III: Solitary Man* set.)

His capacity for heart-stopping garage rock remains undiminished: witness 2008's

Dig, Lazarus, Dig!!! (dubbed a 'gothic rock psycho-sexual apocalypse' by *NME*) and his Grinderman side project. But with collaborators as adaptable as The Bad Seeds, Cave's work has gone on to investigate broader and more nuanced issues of human existence. *The Good Son* (1990) let even more light in, while the piano-led *The Boatman's Call* (1996) – one of his most revered albums – picked apart the nature of love and faith. Two years later, he penned an insightful introduction to Canongate's *The Gospel According to Mark*. There, he envisaged Christ as a creative catalyst in a mundane world ('He gave our imaginations the freedom to rise and to fly'), misunderstood even by his own disciples. Their neglect of Him in the Garden of Gethsemane may have been in Cave's mind for the haunting 'Jesus Alone', from 2016's *Skeleton Tree*. The album introduced layers of dissonance and atonality as a framework for lyrics that ponder how to come to terms with grief. (Cave's young son died suddenly during its recording; the singer reworked some of the album in light of the tragedy.)

Stark and spare, its emotional heft reaffirms him as a songwriter with few peers, a status underlined by the transcendent and reflective follow-up *Ghosteen* (2019).

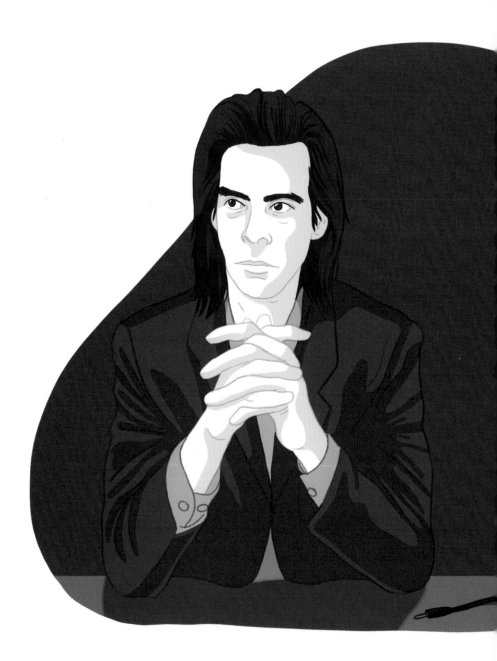

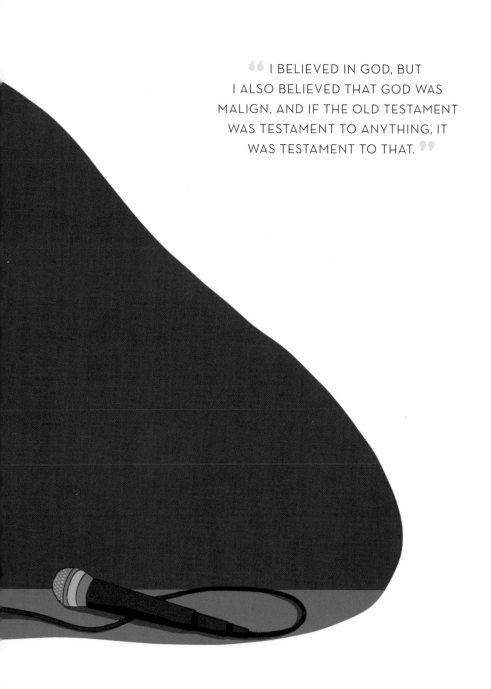

" I BELIEVED IN GOD, BUT
I ALSO BELIEVED THAT GOD WAS
MALIGN, AND IF THE OLD TESTAMENT
WAS TESTAMENT TO ANYTHING, IT
WAS TESTAMENT TO THAT. "

MANU CHAO (1961)

—— REBEL ROCKER

In the 1980s, Chao's group Mano Negra picked up the outlaw spirit of The Clash to become one of the most exhilarating live acts around. Named after a late-19th-century Andalusian anarchist group, their core was frontman Chao, his brother Tonio (trumpet) and their cousin Santiago Casariego (drums). The rest of the ranks were filled with street musicians from France and North Africa encountered in the Paris Métro.

Inclusiveness was a core element of Chao's approach. Mano Negra played a celebratory musical bouillabaisse of punk, rock, flamenco, rap, raï and more that they dubbed 'Patchanka'. The defiantly multicultural collective regularly sold out venues but struggled to make commercial headway. Anarchic by inclination as well as provenance, they eschewed conventional tours and promotional duties; asked to define 'anarchy' on Argentinian TV, they smashed up the studio. (To this day, Chao turns down lucrative offers for his music to appear in TV ads.) Yet despite acquiring a loyal following in Latin America and Europe – territories where he still commands a large and fervid audience – they never cracked the USA or UK and had lost momentum by the mid-1990s.

Thereafter, Chao embarked on a cross-global jaunt, playing in bars, soaking up the street music, overcoming a truckload of personal demons, and playing with various recording ideas (including the sounds of the streets). The triumphant, cross-hybrid results were heard on sleeper hit *Clandestino* (1998), his first solo set, which wound up selling 5 million copies and staying on the French charts for years. His stylistic tic of re-employing backings and lyrics across different songs crops up again on the studio sets *Próxima Estación: Esperanza* (2001) and *La Radiolina* (2007).

Chao has long been a staunchly internationalist political animal, singing in multiple languages, eagerly soaking up different musical styles. Still punk in spirit, he has no time for stardom or stars – well, almost none: 'Every time I met any of my heroes I was disappointed,' he revealed in 2007. 'The exception was Joe Strummer, who was like an uncle to me.' He remains a committed political activist too, regularly taking to social media in support of anti-globalization groups, indigenous communities, women's rights and environmental issues.

Chao's reading of the predicament of migrants heard on *Clandestino*'s title track resonates today more than ever. Factor in his passion and empathy for underdogs everywhere, and he warrants comparison with Bob Marley (whom Chao sang about in 'Mr. Bobby'); in both, radical fire is tempered with compassion.

ALEX CHILTON (1950-2010)

—— POWER-POP NIGHTMARES

As a teenager, Memphis-born Chilton hit it big with The Box Tops, a blue-eyed soul group produced by Dan Penn. Featuring Chilton's raw lead vocals, they scored a US no.1 with 'The Letter' in 1967, followed by a string of other Top 50 hits Stateside.

But it's what he did next that made him a cult icon. Along with guitarist and co-songwriter Chris Bell, Chilton formed power-pop group Big Star, an act indebted to British Invasion bands such as The Beatles (for melody), The Kinks and The Who (for sonic oomph), cushioned in Byrdsian harmonies. *#1 Record* (1972) was giddy, crunchy pop, focused in a way that few contemporary US bands were; Chilton's 'Thirteen' was a highlight, a disarming paean to adolescent love. But shoddy promotion and distribution saw the album sink.

At loggerheads with Chilton over the band's direction, and with violence flaring, Bell quit and Big Star briefly split before Chilton reconvened with bassist Andy Hummel and drummer Jody Stephens for 1974's *Radio City*. Boasting their classic 'September Gurls', it brimmed with exhilarating spontaneity, albeit with an underlying sense of things getting out of control (not least in Chilton's twisted lyrics). Again, despite excellent reviews it had zero label support and stiffed. The edgy *Third/ Sister Lovers* (1978) – largely Chilton's work – was a nightmarish beauty, the dysfunctional drag to 'Kanga Roo' and 'Holocaust' mirroring

Big Star's disintegration and Chilton's dreams turning sour.

His solo career saw intermittent brilliance laced with chaos (exacerbated by booze, drugs and a wilful disregard for his Big Star glories). The polished songcraft and exemplary production of *#1 Record* were gone, but Chilton now slotted in comfortably with the young bands he played alongside at New York's CBGBs, such as The Cramps (whom he produced), the Ramones and Television. *Like Flies on Sherbert* (1979) featured shambolic but endearing takes on songs by everyone from The Carter Family to KC and the Sunshine Band. His sporadic output thereafter saw an intriguing collaboration with Tav Falco in psychobilly/ roots rockers Panther Burns, intermittent touring and the occasional oldies concert with the original Box Tops. By the 1980s, Chilton and Big Star were receiving namechecks from artists such as REM, The Bangles (who covered 'September Gurls', enabling Chilton to buy a car for the first time in years) and The Replacements, who released tribute single 'Alex Chilton' in 1986.

Chilton paired enviable songwriting skills and a born writer's sensitivity with an unsettling edginess. His reluctance to acknowledge Big Star's belated acclaim may have been rooted in the trauma they experienced and the failure to live up to their name. But you can't keep a good song down.

ALICE COLTRANE (1937-2007)

—— SPIRITUAL PILGRIM

Alice Coltrane – born Alice McLeod – studied classical music as a child, going on to play keyboards at her Baptist church, and bebop piano in the clubs of her native Detroit. Having briefly studied with Bud Powell in Paris, her improvisatory skills and trance-like deliveries made her an in-demand pianist, and by 1966 she had joined saxophonist John Coltrane's quintet (and married him). Both had been brought up in the Christian faith but were now exploring other spiritualities (a quest that informed his acclaimed 1965 set, *A Love Supreme*).

Coltrane's death in 1967 devastated Alice, resulting in weight loss, sleeplessness and hallucinatory episodes. But after meeting guru Swami Satchidananda, she began to refocus and devote her energies to creating a transcendent new music.

Before his death, John had ordered a harp, seeking to expand his musical palette, but it only arrived after his passing. Alice subsequently learned how to play the instrument, becoming an outstanding performer. She developed an eclectic orchestration for her compositions, featuring cascades of strings and harp alongside drone instruments such as the tamboura. Modal jazz, gospel, psychedelia, blues and non-Western scales became touchstones for her music. Her celebrated *Journey in Satchidananda* (1970) draws on ancient mythologies (particularly those of North Africa and India) in a soundscape that implies flow and continual process rather than finite beginning and ending, with liberating glissandos from Alice's own harp. This is music-making as a worshipful and unifying act.

In the mid-1970s, Alice founded a vedic practice – The Vedantic Centre – in California. In the early 1980s she relocated it to the state's Santa Monica mountains, with the new title Shanti Anantam Ashram, and became its spiritual director, renaming herself Turiyasangitananda ('the Transcendental Lord's highest song of Bliss'). As well as overseeing devotional services, she recorded cassettes for members of the ashram, which she based on traditional Sanskrit chants but elaborated on with ambitious and bold arrangements, incorporating synthesizers and featuring her own singing for the first time. (A 2017 compilation of her ashram tapes, on Luaka Bop, was rapturously received.)

Alice's devotion to spiritual matters necessitated a hiatus from public performance, but renewed interest in her work saw a comeback in the new millennium, with the fêted album *Translinear Light* (2004) and a handful of US concerts. By the time of her death, she had both built on the visionary journey she had begun with her late husband and established herself as a unique artist in her own right.

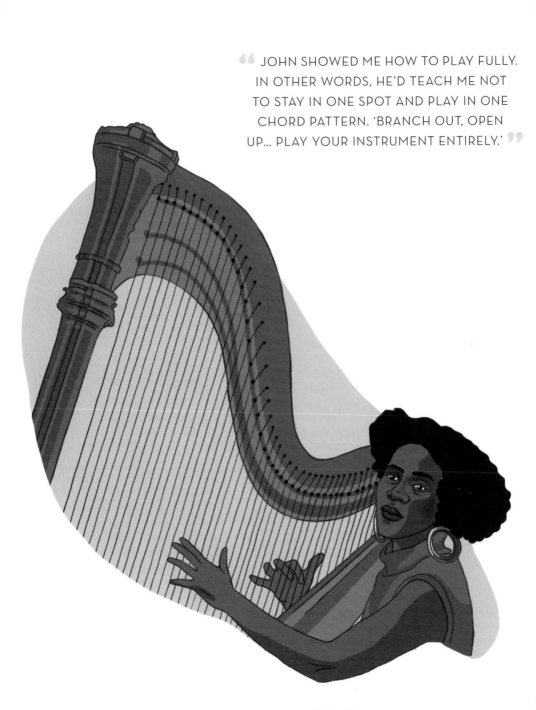

"JOHN SHOWED ME HOW TO PLAY FULLY. IN OTHER WORDS, HE'D TEACH ME NOT TO STAY IN ONE SPOT AND PLAY IN ONE CHORD PATTERN. 'BRANCH OUT, OPEN UP... PLAY YOUR INSTRUMENT ENTIRELY.'"

BETTY DAVIS (1945)

—— NO-NONSENSE FUNK-ROCKER

An under-rated figure in the pantheon of pop, Davis demands attention both for her own recordings and as a pivotal influence on a jazz legend.

As a teenager in the early 1960s, the then Betty Mabry moved to live with an aunt in New York, swiftly assimilating into hipster Greenwich Village, socializing with students, actors and musicians at the Cellar club, and becoming a model. She had been songwriting from an early age, and in 1967 her 'Uptown (to Harlem)' appeared on The Chambers Brothers' acclaimed set *The Time Has Come* (1968). She met and briefly married jazz icon Miles Davis, although his tempestuous moods soon saw them part. But Betty introduced him to Sly Stone-style psychedelic rock, almost brokered an artistic collaboration with Jimi Hendrix, and helped to pave the way for Miles's ground-breaking jazz-fusion excursion *Bitches Brew* (1970).

Betty's own musical career came to spectacular fruition in the early 1970s. Backed by a crack band including funk legend Larry Graham, former Sly Stone drummer Greg Errico, and future disco stars Sylvester and The Pointer Sisters, her self-arranged eponymous 1973 debut album was astonishing for its time, blending tough funk and hard rock with frank and sexually assertive lyrics ('If I'm in Luck I Might Get Picked Up' is an aggressive statement of intent) delivered in Betty's raspy growl. Way before Madonna, let alone Lil' Kim or Nicki

Minaj, she was laying claim to a woman's rights, in the bed and – by implication – out of it. A commercial non-starter, the album nonetheless aroused enough scandal to see some concerts pulled (she was a no-holds-barred performer, too) and a partial radio ban.

The equally outré *They Say I'm Different* (1974) explored S&M on 'He Was a Big Freak', while 'Don't Call Her No Tramp' tackled the double standards that saw Betty pilloried for articulating urges that male rock stars voiced regularly. (The song was even too much for the National Association for the Advancement of Colored People (NAACP), who requested it be banned on black radio.) *Nasty Gal* (1975), her first set for Island Records, explores similarly risqué ground over a tight funk template courtesy of Funk House; the calibre of her bands was vital to the sonic punch of these releases. But despite admiring reviews, it sank, its hard funk/rock hybrid too heady for both black and white audiences.

With disco on the horizon, this outsized, dancefloor-friendly personality seemed primed for stardom. Instead, after Island shelved her fourth set she more or less disappeared from view. But she'd already created a legacy too powerful to perish, one that lives on in dynamic, empowered artists such as Peaches, Missy Elliott, Erykah Badu and Janelle Monáe.

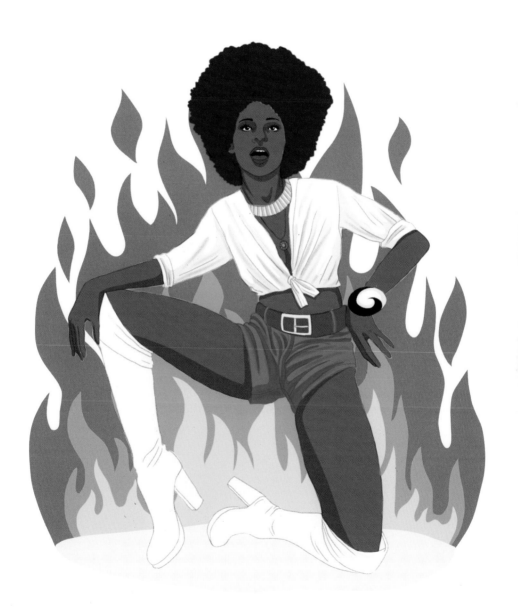

SANDY DENNY (1947-1978)

—— PEERLESS FOLK SINGER

One of British folk music's most gifted performers, Sandy Denny possessed a voice of exceptional purity, almost entirely without vibrato. She helped pioneer folk-rock in the UK with Fairport Convention and was highly esteemed by her peers (the only outside musician to appear on a Led Zeppelin recording, she duets with Robert Plant on 'The Battle of Evermore' in 1971). But personal demons and a crippling lack of self-belief undermined her.

Denny joined the Fairports in 1968 and immediately proved herself as an interpreter of distinction – her take on Bob Dylan's 'I'll Keep it with Mine' comfortably transcends the original, and her reading of the traditional 'She Moves Through the Fair' is sublime. But her self-compositions, such as 'Fotheringay' – the opening track on her first album with the band, *What We Did on Our Holidays* (1969) – were compelling in their own right. On her signature song, 'Who Knows Where the Time Goes', from their next set, *Unhalfbricking* (1969), she sounds both forgiving and worldly wise, though she'd penned it when she was just nineteen. The album features a transcendent version of 'A Sailor's Life'; in a game-changing electric take on this traditional folk ballad, her vocal is transfixing. British folk-rock proper was born with the follow-up, *Liege & Lief* (1969).

She left the Fairports before *Liege & Lief*'s release, forming Fotheringay with boyfriend Trevor Lucas, then endured a troubled career as a solo star and even rejoined Fairport Convention for a poorly received reunion. Although she'd twice topped music paper *Melody Maker*'s poll for Best Female Artist (in 1971 and 1972), neither of her first two excellent solo sets were major hits. She became obsessively averse to solitude, so much so that she paid backing groups on a retainer, despite the cost. Drink, cocaine and the philanderings of Lucas (now her husband) further damaged her low self-esteem. She died in 1978, aged just thirty-one, after a fall.

Denny's voice pierced listeners to the emotional quick; when she sustains a note, it seems to pause time itself. There's a peculiarly English melancholy in there too – just listen to her reading of 'Blackwaterside' on her first solo album, *The North Star Grassman and the Ravens* (1971). Denny's singing played a key role in Fairport Convention's knack of bringing songs that spoke of Albion's mystic past into the daylight of the present, and offered the consoling – and even cathartic – confirmation that loss and heartache are as old as love.

DELIA DERBYSHIRE (1937-2001)

—— GODMOTHER OF ELECTRONICA

This pioneering sound designer will always be best remembered for BBC TV's *Doctor Who* theme. But the scope of her work with the Radiophonic Workshop – the BBC's experimental sound-effects department – was far broader. That she achieved so much in the face of entrenched sexism within her industry makes her an undersung feminist icon.

Derbyshire joined the BBC in 1960 as a trainee studio manager. (Decca Records had rejected her – their studios were a male-only preserve.) She swiftly migrated to the Radiophonic Workshop, to develop her interests in music theory and the emotional impact that electronic sounds could have; she employed rigorous sonic analysis to generate rich electronic textures, while also filtering and treating found sounds. (The air-raid sirens she heard as a child during World War II were a pivotal inspiration.)

Her radical treatment of the *Doctor Who* theme – described by Orbital's Paul Hartnoll as 'the single most important piece of electronic music' – was based on a musical sketch by Ron Grainer. In 1963 – decades before sophisticated audio software packages – Derbyshire used test oscillators and white noise to create original samples that she could manipulate, running three tapes on three machines concurrently to create that startling sound. She received no royalties for it: BBC policy dictated that staff remained uncredited.

Told that her music was too 'lascivious' for younger viewers, and went over the heads of BBC2's adult audience, she moonlighted as a composer for films, theatrical plays and avant-garde events. Another outlet came in the form of electronic groups, including White Noise, with whom she produced the ahead-of-its-time *An Electric Storm* (1969).

Derbyshire's work won her some high-profile fans: in 1966, Paul McCartney visited her, reportedly to add some field electronica to a reworked 'Yesterday'; she scored one of Yoko Ono's films, and was visited at the Radiophonic Workshop by an inquisitive Brian Jones. She also collaborated with Peter Maxwell Davies and worked at a summer school as Luciano Berio's assistant.

She left the BBC in 1973, having soundtracked some 200 TV and radio shows. By the mid-1970s, irked by electronic music (she felt synthesizers discouraged atonality), she retired, but was eventually coaxed back by Spacemen 3 co-founder Peter Kember to collaborate on two of his releases as Experimental Audio Research (EAR). Her exhilaration was plain: 'Now, without the constraints of doing "applied music", my mind can fly free and pick-up where I left off.'

As a sonic pioneer, Derbyshire surely ranks alongside Karlheinz Stockhausen or Pierre Schaeffer. Yet unlike them, she brought radical electronic soundscapes into family living rooms every week.

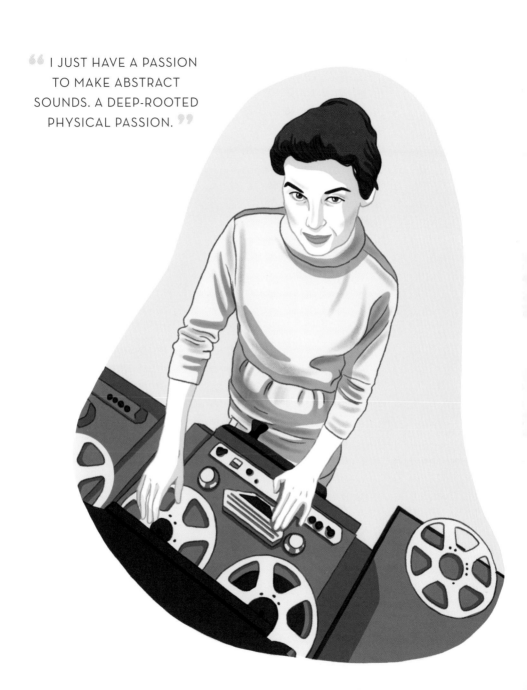

" I JUST HAVE A PASSION TO MAKE ABSTRACT SOUNDS. A DEEP-ROOTED PHYSICAL PASSION. "

NICK DRAKE (1948-1974)

—— A SKIN TOO FEW

In the space of just three albums, Nick Drake mapped out a captivating, understated sound world. The reverence in which he is held today would doubtless bemuse him, but then his commercial failure while he was alive did the same.

Born into a comfortable middle-class home, Drake was educated at Cambridge University. In 1968, American producer Joe Boyd heard one of his tapes and was immediately struck. Like Syd Barrett, Drake's vocal delivery was distinctly English ('at the aristocratic end of "received pronunciation"', as Boyd observed), while his accomplished guitar-playing incorporated proficient finger-picking and open tunings.

Debut *Five Leaves Left* (1969) introduced the crepuscular, autumnal sound characteristic of Drake's output, heard to mesmerizing effect on 'River Man'. At the start of his twenties, Drake's hushed delivery sounds more like the reflections of a man in his twilight years, set against a lithe string arrangement by Robert Kirby that swoops in and around the vocal like a flight of swallows. *Bryter Layter* (1971) struck a more upbeat tone on 'Hazey Jane II' and the self-deprecating 'Poor Boy', while 'Northern Sky' may well be Drake's finest, a disarming serenade shrouded in a halo of John Cale's keyboards, and described by *NME* some thirty years later as the 'greatest English love song of modern times'. *Pink Moon* (1972) was a bleaker listen, though, stripped down to Drake's voice, acoustic guitar and piano, its melancholy giving rise to comparisons with blues legend Robert Johnson. The connection is even clearer on 1974's 'Black-Eyed Dog', from one of Drake's final recording sessions (Winston Churchill had used the term to describe his depressions).

None of them sold.

After the failure of his second album, Drake's mood darkened considerably. He was prescribed anti-depressants, which he was reluctant to take (not least because he

was now a heavy cannabis user). His mental state and appearance – stooped posture, unwashed hair, long fingernails – had been deteriorating for some time, hence the use of artwork, rather than photographs, for *Pink Moon*'s sleeve. In early 1972, he had a breakdown. He returned to live at his parents' home in Tanworth-in-Arden. There, in November 1974, he overdosed on anti-depressants under circumstances that still remain unclear.

By the 1980s, helped by the release of Island's 1979 *Fruit Tree* box set, appreciation of Nick Drake was finally on the rise. A line from 'Time Has Told Me' inspired Robert Smith to name his band The Cure. REM's

Peter Buck, Television's Tom Verlaine, Lucinda Williams and Robyn Hitchcock have sung his praises. 'Northern Sky' inspired The Dream Academy's hit single 'Life in a Northern Town'. Drake's influence is audible on early records by Belle and Sebastian and Badly Drawn Boy, while Paul Weller's pastoral *Wild Wood* album also owes a debt to the too-soon-gone singer.

When you get Nick Drake, you really *get* him. Joe Boyd knew that; when he sold his production company to Island, one of the conditions was that Nick Drake's back catalogue would never be deleted.

I CAN'T COPE, ALL THE DEFENCES ARE GONE. ALL THE NERVES ARE EXPOSED.

BRIAN ENO (1948)

—— THE THINKING PERSON'S NON-MUSICIAN

Brian Peter George St John le Baptiste de la Salle Eno set up his tent in the leftfield early on and hasn't budged since. Omnivorously intellectual and incurably curious, his outside-the-box approach to music-making has seen acts as diverse as David Bowie, U2, Devo and Talking Heads seek him out as a producer, although his back catalogue alone would have earned him a place in these pages.

Born in Suffolk, Eno studied experimental music at art school in Ipswich, followed by a spell at Winchester School of Art. His realization that you didn't need to be a musician to make music paid handsome dividends for his first band, glam-rock retro-futurists Roxy Music. Eno processed the band's sound live, from the mixing desk, and conjured atmospheric sci-fi sonics from his synth onstage. Coquettishly festooned in boas, berets and lipstick, he rather drew attention from the band's frontman, Bryan Ferry. That tension, and Eno's boredom with

rock-star life, saw him quit in 1973 after just two albums.

HIs first few solo sets were diverse art-rock affairs, equally at home with the punk-like riffs of 'Third Uncle' and communal singing ('Taking Tiger Mountain (By Strategy)'). But from the mid-1970s he began working on what became 'ambient music' – instrumentals intriguing enough to be listened to in their own right, but also capable of serving as background colour – first heard wholesale on 1975's *Discreet Music*. (In the early 20th century, Erik Satie had come up with a similar idea, which he termed 'furniture music'.)

From 1977 to 1979, Eno worked with David Bowie on the so-called 'Berlin Trilogy' of *Low*, *"Heroes"* and *Lodger*. His input lay not only in 'treating' (his term) recorded sounds, but rethinking the studio as a compositional tool in itself. He drew on his art-school training for ways to break up conventional music-making – famously with

his Oblique Strategies cards, each inscribed with an instruction designed to provoke musicians into overcoming ingrained habits.

Perhaps only a non-musician would have thought of sampling radio broadcasts and layering them over a musical bedrock, as Eno (and Talking Head David Byrne) did for 1981's *My Life in the Bush of Ghosts*. Hip-hop pioneers took note. In the 1990s, inspired by the ever-changing patterns of computer screensavers, Eno developed what he termed 'generative music', self-producing sounds that are almost infinitely non-repetitious; 1996's *Generative Music 1* employed software to achieve those ends, although he'd manipulated tape loops to similar effect on 1975's *Discreet Music*.

Eno's polymath appetites have fuelled the exploration of far-flung fields that are off the map for most musicians. He belongs to the Long Now Foundation, which seeks to refocus our perspective on life from the increasingly short term to the millennially long term, thereby promoting meaningfully far-sighted plans for humanity and our planet. Eno's *Bell Studies* (2003) were inspired by the idea of creating chimes for a clock (designed by Daniel Hillis) that would sound every 10,000 years. This one-time student of experimental art is also a practising video and installation artist who has worked with Laurie Anderson, among others. Eno's wondrous *Thursday Afternoon* (1995) album was created as the soundtrack for seven video-paintings by his friend Christine Alicino.

" WHEN I STARTED MAKING MY OWN
RECORDS, I HAD THIS IDEA OF DROWNING
OUT THE SINGER AND PUTTING THE
REST IN THE FOREGROUND. IT WAS THE
BACKGROUND THAT INTERESTED ME. "

ROKY ERICKSON (1947-2019)

—— PSYCHED

During their brief mid-1960s heyday, Erickson's Texan band The 13th Floor Elevators were one of the most original outfits around, coupling a vibrant and raw garage-punk sound (featuring an amplified blown jug) with lyrics that enthusiastically proselytized for LSD. They lived what they preached, too – and therein lay the root of at least some of their problems.

The chief architect of the Elevators' acid philosophy was jug player Tommy Hall, but Erickson was their cherubic-faced, visceral vocalist (he reportedly tutored fellow Texan Janis Joplin on how to screech without harming her larynx). Erickson penned the timeless kiss-off 'You're Gonna Miss Me' for previous band The Spades, which became the Elevators' sole *Billboard* chart placing (no.55) in 1966. He was also the key songwriter on statement-of-intent *The Psychedelic Sounds of The 13th Floor Elevators* (1966) and the more reflective *Easter Everywhere* (1967) – which opened with his mighty 'Slip Inside This House', later reworked by Primal Scream. They remain two of the era's defining albums.

Erickson had had mental disorders since his mid-teens, issues that were exacerbated by the band rehearsing and playing live while tripping. Arrested for marijuana possession in 1969, he opted for a spell in a psychiatric hospital but, after several escapes, was incarcerated in a maximum security unit for the criminally insane in Texas's Rusk State Hospital, where he underwent electroshock treatment and was given the anti-psychotic drug Thorazine. Thereafter, Erickson cut an increasingly sorry figure, declaring himself an alien and filling the shack he lived in with the sound of white noise from multiple radios and TV sets. It's remarkable that he was able to produce any music at all, yet his solo career offered up definite highlights (the material largely revolved around schlock horror, devilry and the occult) and found him in excellent voice. Thankfully, after his younger brother, Sumner, became his guardian in 2001, the quality of Erickson's medical care improved, along with the convoluted state of his contractual history and his royalty income. Uplifting comeback gigs in the early 2000s affirmed that his talent lived on.

But Roky Erickson's legacy lies in that primal cache of songs from 1966 and 1967. His passionate rock 'n' roll holler and rhythm guitar drove the Elevators' sound, placing them ahead of the game when San Franciscans the Grateful Dead and Jefferson Airplane were still folk-rockers trying to go electric. That spirit inspired a host of younger artists, from fellow Texans ZZ Top to R.E.M., Julian Cope and The Jesus and Mary Chain, all of whom contributed to a 1990 Erickson tribute album.

MARIANNE FAITHFULL (1946)

—— INDOMITABLE CHANTEUSE

In her long list of achievements, simply surviving is perhaps her greatest. Faithfull's journey from teenage ingénue to septuagenarian legend has taken her perilously close to the edge over which many of her peers disappeared.

Her first brush with fame came with 1964's 'As Tears Go By', recorded when she was seventeen and penned by Rolling Stones Keith Richards and Mick Jagger. Within two years, however, she had given birth to a son (Nicholas), married artist John Dunbar, then left him for a new lover: Jagger. They became one of the decade's most iconic couples, although Faithfull's time in The Stones' circle introduced her to drugs and, with a police bust at Richards' home in 1967, gave her unwanted notoriety. In 1970, she split with Jagger, miscarried his child and lost custody of Nicholas to his father. Devastated, she attempted suicide.

Thereafter, the abyss: Faithfull's appearances became sporadic and she spent a couple of years as a homeless heroin addict in Soho. By the time of her triumphant return with 1979's new wave-influenced *Broken English* – on which she addressed infidelity, sex and wasted lives with dry-eyed clarity – drug abuse and laryngitis had deepened her voice and added a raw timbre. Faithfull had become a post-punk chanteuse, an astute interpreter of others' material and a potent songsmith herself. (She'd contributed to several Stones songs, but only belatedly received a co-writing credit for their track 'Sister Morphine'.) *Strange Weather* (1987) – interpretations of songs by Bob Dylan, Tom Waits and Lead Belly, among others – was another strong set.

A talented actress, Faithfull had performed alongside Glenda Jackson in Chekhov's *Three Sisters* in 1967 and appeared in cult movies *The Girl on a Motorcycle* (in tight leather, which only enhanced her infamous reputation) and Kenneth Anger's *Scorpio Rising*. In 1991, she took to the stage

> 66 I'M NOT REALLY ENGLISH, I'M EUROPEAN. THAT'S WHY KURT WEILL IS VERY ME. DO YOU KNOW HOW MANY PEOPLE HAVE TRIED TO CLIMB THAT BRECHT-WEILL MOUNTAIN AND FAILED? BUT BECAUSE OF MY BACKGROUND I UNDERSTOOD IT INTUITIVELY. 99

of The Gate in Dublin for Kurt Weill's *The Threepenny Opera*. Its decadence, world-weariness and dark humour fitted her well, and she revisited the territory with her show 'An Evening in the Weimar Republic', the live *20th Century Blues* album (vivid readings of Weill and Brecht's 'Alabama Song', 'Pirate Jenny' and 'Mack the Knife', among others) and on stage in Weill's *Seven Deadly Sins* at Austria's Linz State Theatre in 2013.

Admirers including Jarvis Cocker, Damon Albarn, PJ Harvey, Anna Calvi and Nick Cave have written with or for her. Faithfull has also revisited her earlier oeuvre, imparting it with far greater emotional heft. Illness and the loss of close friends (including Keith Richards' former partner Anita Pallenberg) have rocked her. Then again, as she says, 'There's nothing like real hardship to give you some depth.'

> **IT'S AN OLD THING THAT WOMEN ARE MEANT TO SOUND PRETTY AND FEMININE. BULLSHIT! I ALWAYS LOVED JANIS JOPLIN AND BILLIE HOLIDAY. IN THEM I HEAR THE BLUES.**

STONES: 'A ST[...]
SMELL OF IN[...]

Stones:
switch
on way
to court

Rolling Stone
Brian remanded

Art man's
sentence
to stand

Story of girl in
fur-skin rug

BRIGITTE FONTAINE (1939)

—— DOYENNE OF AVANT-GARDE FRENCH POP

Before embarking on her singular musical career, Fontaine was an established performer in experimental theatre and a published playwright. Her play *Maman j'ai peur* proved hugely popular in Paris, opening to great critical acclaim, and went on to tour Europe. As a singer, she had supported George and Barbara Brassens in 1963, although her debut album, *13 chansons décadentes et fantasmagoriques*, only arrived three years later. She disowned it, however, citing 1968's *Brigitte Fontaine est... folle!* as her true beginning. (Its orchestrator, Jean-Claude Vannier, later worked on Serge Gainsbourg's 1971 masterpiece *Histoire de Melody Nelson*.) Quirky rather than controversial, the songs embrace tribal rhythms ('Éternelle') and the sounds of tropical birds ('Blanche Neige'). Fontaine eschewed conventional pop song structures and melodies for a husky, spoken-word delivery influenced by her background in avant-garde theatre. Her early years of stage performance also helped her to develop the extraordinary elasticity of her vocals, capable of rising from a hushed coo to a vibrant shriek within the span of a song. Her lyrics address paranoia, lunacy, alienation, but are seasoned with humour too.

Comme à la radio (1969) remains one of her most acclaimed works. A collection of strange, folk-like pieces incorporating non-Western instruments, North African rhythms and Eastern-sounding melodies, it has been lauded by latter-day artists including Sonic Youth and Beck, and marked the start of her long-term partnership with Algerian musician Areski Belkacem. Avant-garde jazz combo the Art Ensemble of Chicago provided the ethereal backing.

Follow-up *Brigitte Fontaine* (1972) dialled down the extremes for a diverse jazz–pop set, although Fontaine and Belkacem were to become increasingly experimental during the decade. The remarkable double album *Vous et Nous* (1977) features songs of wildly differing lengths (some less than a minute) and embraces synthesizers and processed drum sounds alongside the African and Eastern European instrumentation heard on earlier releases.

Her eclectic style meant she was never destined for commercial success, but by the 1990s younger artists were rediscovering Fontaine's earlier work, leading to collaborations. In turn, she embraced contemporary production values and trends – witness the drum 'n' bass stylings of *Les Palaces* (1997). Stereolab (whose 'Brigitte' is a tribute to Fontaine) teamed up with her for the single Caliméro (1998), while she worked with Sonic Youth (and jazz saxophonist Archie Shepp) on her 2001 set *Kékéland*, and combined with a number of her admirers, including Jarvis Cocker, for a performance of Gainsbourg's *Histoire de Melody Nelson* in London in 2006. Now in her seventies, this angular underground icon continues to confound expectations.

SERGE GAINSBOURG (1928–1991)

—— ENFANT TERRIBLE SANS PAREIL

Obscenities litter Gainsbourg's recordings. His biggest (and banned) hit fluttered with soft-core moans. He recorded a duet with his daughter entitled 'Lemon Incest'. On live TV, he burned a 500 franc note and, on another occasion, made an explicit proposal to Whitney Houston. Of course, he is also a French icon.

Like an incurably hedonistic feline, Gainsbourg lived more than just the one life. His early oeuvre was peppered with intellectual, twisted songs (his first major success was the tale of a Métro ticket puncher who shoots himself), adding touches of jazz and world music to French *chanson*. But although this prolific songwriter could write hits for Juliette Gréco, Petula Clark and even Luxembourg (1965's Eurovision Song Contest winner 'Poupée de cire, poupée de son', sung by France Gall), he himself was not a star. When Brigitte Bardot challenged him to write a sublime love song in penance for a disastrous dinner date, he wrote two: 'Je t'aime... moi non plus' and 'Bonnie and Clyde'. The former finally gave him a hit – when rerecorded with a later lover, Jane Birkin (twenty years his junior) –selling 6 million copies worldwide.

He followed it with *Histoire de Melody Nelson* (1971), a concept album about a middle-aged man's love for a teenage girl whom he knocks from her bicycle.

Symphonic, psychedelic and wondrously poetic, it is his most celebrated set but sank ignominiously at the time. Seemingly incapable of releasing a straightforward record, Gainsbourg's next studio set was 1975's Hitler-themed *Rock around the Bunker* (shocking? Certainly, though Gainsbourg was a Jewish refugee). He caused further upset with his reggaefied version of 'La Marseillaise' on 1979's *Aux armes et caetera* (the musicians included Sly & Robbie and the I Threes); the subsequent tour saw bomb scares. Each new release conflated art with controversy (1984's *Love on the Beat* takes in prostitution and incest, and finds Serge in drag on the sleeve). But his insatiable appetites for Gauloises and booze (he dubbed his drunkard alter ego 'Gainsbarre') were catching up with him, and the last of a string of heart attacks claimed him in 1991. Paris went into mourning, while a fulsome tribute from President Mitterrand ranked him alongside Proust and Baudelaire.

A provocative, dextrous poet and musical chameleon, equally at home with high art and scatology, Serge Gainsbourg has influenced a multitude of artists as diverse as Air, Sonic Youth and Petula Clark. He reshaped not only his nation's pop but its culture too, the anti-star whom the French establishment adored.

UGLINESS HAS MORE GOING FOR IT THAN BEAUTY. IT ENDURES.

BOBBIE GENTRY (1942)

—— SOUTHERN STAR

Born Roberta Lee Streeter, Bobbie Gentry was the complete package: a prolific and richly gifted singer-songwriter blessed with glamorous good looks; an assured producer in the recording studio; a savvy businesswoman. And the subject of one of pop's most mysterious disappearing tricks.

Capitol A&R man Kelly Gordon caught one of Gentry's club sets in early 1967 and demoed some of her songs, including 'Ode to Billie Joe'. Its conversational narrative belied the dark subject of a youthful suicide, set to Gentry's plucked parlour guitar and a queasy string arrangement. Markedly out of step with the psychedelic times, it nonetheless rocketed to no.1 in the US. Her debut LP *Ode to Billie Joe* (1967) was a modest hit, while the more experimental follow-up, *The Delta Sweete* (1968), offered perceptive snapshots of Deep South life paired with rootsy backings. It fared less well, and the same year's exquisite *Local Gentry* – pin-sharp portraits of characters drawn from the same cultural patch – was similarly overlooked. Yet this work placed Gentry as an accomplished artist in the Southern Gothic tradition, alongside writers such as William Faulkner and Flannery O'Connor.

By summer 1968, Gentry had her own British variety show on BBC2, eventually assuming script-writing, choreography and costume design duties. There were further sporadic hits (including duets with Glen Campbell), while her breezy reading of the Bacharach and David tune 'I'll Never Fall in Love Again' was a UK no.1 in 1969. Its parent album, *Touch 'Em with Love*, was another artistic triumph, encompassing Southern funk, gospel and bluegrass, topped off by Gentry's sultry rasp. But her commercial star was waning. After two more strong sets (*Fancy* (1970) and *Patchwork* (1971)), she devoted her considerable energies to staging lavish live shows in Las Vegas.

A tough childhood made Gentry resolve never to be poor. Her single-mindedness finds an echo in 1970's 'Fancy', wherein an impoverished mother grooms her daughter to become a high-class call girl to escape poverty (Gentry regarded it as her 'strongest statement for women's lib, if you really listen to it'). She owned her own production company, purchased considerable amounts of Californian real estate and had a share in the Phoenix Suns basketball team. That same single-mindedness saw her quietly retire from the entertainment business in the early 1980s, following which she has remained firmly out of the public eye.

In truth, she had nothing left to prove. Her songs are as nuanced and crafted as the pick of her peers. A consummate all-round entertainer, she took charge of her own career, breaking ground for female artists who followed. She was the girl from Chickasaw County who could do it all – and did.

PJ HARVEY (1969)

—— SHAKE-UP ARTIST

Dorset-born Polly Jean Harvey set out her stall with the acclaimed singles 'Dress' (1991) and 'Sheela-Na-Gig' (1992) as part of the trio PJ Harvey. Both were gathered on *Dry* (1992) – one of Kurt Cobain's favourite albums – her first comprehensive major statement. The immediate success saw the young singer start to cave under the pressure of expectation, but a label change (to Island) and a new producer (Steve Albini) resulted in another, more visceral triumph, *Rid of Me* (1993). Tensions arose among the three-piece while touring the USA, however, and they parted, Harvey now gaining in confidence to become a solo artist, bolstered by the considerable success of the album.

To Bring You My Love (1995) forsook the hard edges and riffery of her first two sets with a more lush sound (courtesy of producer Flood) and somewhat less intense approach (witness 'Meet Ze Monsta'), though still featuring her characteristically driven vocals. Featuring a US modern radio hit in the brooding 'Down by the Water', it was voted album of the year by a number of publications, including *Rolling Stone*.

Stories From the City, Stories From the Sea (2000) – altogether more pop-oriented and polished – secured Harvey her first Mercury Prize. By now, Harvey was capable of confidently embracing any range of musical direction – indeed, critics were interpreting every new album as a reaction to the one that came before. True to form, she adopted an entirely different sound for the grief and ghostly balladry of *White Chalk* (2007), incorporating piano and autoharp, which inveigled the set with an eerie, antiquated air. Harvey draws on a broad spectrum of influences, and not all of them necessarily autobiographical; preparing for this album, she immersed herself in the penetrative psychological portraits in the works of Russian novelists such as Tolstoy

and Dostoevsky. And like David Bowie in his imperial phase, her restless reinvention applies to her vocal style: the full-throated blues bawl of *Dry* gave way to a quieter, almost childlike voice for *White Chalk*.

In another reinvention, her next album, *Let England Shake* (2011), took a cold-eyed, sometimes mournful look at English nationhood and nationalism. A wide-ranging assessment, it drew on conflicts from World War I's Gallipoli campaign to the contemporary Afghanistan conflict, while its artistic touchstones included Goya's horror scenes in 'Disasters of War' (notably in the grisly 'The Words That Maketh Murder'). It gave the singer her second Mercury Prize – an unprecedented feat.

It's a mark of her artistic scope and ambition that Harvey regularly sets herself new, sometimes uncomfortable challenges. In January 2015, sessions for her ninth set, *The Hope Six Demolition Project* (2016), saw the singer and her band set up in a room-sized cube within London's Somerset House as a living art installation, in collaboration with arts organization Artangel. Titled *Recording in Progress*, the project allowed the public to watch the musicians' creative process through one-way glass. It gave Harvey her first UK no.1 – although this maverick artist started setting her own benchmarks for success long ago.

" I ALWAYS WANT TO BE
EXPERIMENTING AND GOING
INTO NEW AREAS BECAUSE IT
STIMULATES ME AS AN ARTIST. "

MARK HOLLIS (1955-2019)

—— LESS IS MORE

Think of a painter, having produced a rich and satisfying canvas, slowly paring it back until only the barest and truest elements remain. Welcome to the world of Mark Hollis.

His band, Talk Talk, enjoyed considerable success in the early 1980s with chart-friendly hits distinguished by Hollis's driven vocals, such as 'Talk Talk' and 'It's My Life'. The latter's success in the USA bumped up the budget for their third album, *The Colour of Spring* (1986), and Hollis took full advantage, envisaging a more organic sound and introducing random elements of chance to the recording process. Taken from that album, 'Life's What You Make It' was a hit Stateside, prompting label EMI to give the band an unlimited budget for its follow-up. The single's spine-tingling B-side, 'It's Getting Late in the Evening', pointed to where Hollis was heading next with its fragile vocal and spartan backing.

Marking a radical shift, the mesmerizing *Spirit of Eden* (1988) incorporated elements of jazz, classical, blues and – crucially – silence. Over ten months of recording, Hollis explored countless nuances of texture and sound, encouraging improvisation from the other musicians; the studio became a dark, sealed space, sparsely lit by candles, strobes or oil projectors, and the results were then painstakingly edited with producer Tim Friese-Greene. The album

reached no.19 in the UK, but sales were poor compared to its predecessor.

Unfazed, Hollis went even further out on *Laughing Stock* (1991), released on new label Polydor. The hypnotic first two tracks come in at around ten minutes each, opener 'After the Flood' an absorbing, tense listen, release coming with the mellow 'New Grass'. Time stands still in this music. Collectively, the album and its predecessor anticipate post-rock and the free-ranging textures of bands such as Radiohead or Sigur Rós; at the time, though, *Laughing Stock* charted for just two weeks and was rapidly deleted by Polydor. Unsurprisingly, Hollis's exacting and time-consuming focus on detail had worn down his bandmates, Lee Harris and Paul Webb, both of whom quit. After a seven-year hiatus, Hollis's acoustic-toned eponymous solo album appeared, another work of intimate, minimalist beauty.

And that – aside from the occasional abortive TV or movie soundtrack commission – was more or less that. Henceforth, Hollis prioritized home life. He took time to motorcycle across Europe, the USA and South America, saw friends and enjoyed life quietly. He even befriended Kate Bush, although they never collaborated. In truth, the wealth of extraordinary music he'd already recorded is more than enough for one life.

J DILLA (1974–2006)

—— THE HIP-HOP MOZART

The artist born James Dewitt Yancey squeezed an abundance of innovation into his thirty-two years, though the scope of his achievements was only appreciated posthumously. He'd begun making beats in his Detroit home when he was only eleven, then around a decade later he began his production career with A Tribe Called Quest, although his first prick-up-your-ears moment came with The Pharcyde's worldly-wise 'Runnin'' (1995).

Unlike most contemporary producers, Dilla valued imperfections in sound. He worked with unquantized beats (those not perfectly synced by music software) to create a less robotic, more human sound. He built up lengthy passages without using loops, giving the impression that they had been created by a living musician. His gift for melodic invention made the mix richer still, complemented by the way he reworked samples into something invigoratingly new – a practice that lies at the heart of the best hip-hop and which saw him become a major player in late 1990s neo soul and production outfits The Ummah and Soulquarians.

Produced by Dilla, the Tribe's *Beats, Rhymes and Life* (1996) was Grammy-nominated (he also collaborated on Q-Tip's fêted 1999 album, *Amplified*), while his work on Common's *Like Water for Chocolate*, *Voodoo* by D'Angelo, and *Mama's Gun* by Erykah Badu, all from 2000, remain high-water marks of the genre. Not that

his contributions were always obvious: sometimes he went uncredited, as on Janet Jackson's 'Got 'Til It's Gone' (1997). His own vocals were also heard intermittently on 2001's *Welcome 2 Detroit* (his showcase for the city's MCs) and the 2003 Madlib collaboration *Champion Sound*. Posthumous solo set *The Diary* – recorded in 2002 but released in 2016 – turned the spotlight on Dilla as a rapper, though his performance was outshone by the strength of his own innovative production.

The instrumental *Donuts* (2006) appeared on Dilla's thirty-second birthday and is a triumph, demonstrating a richly varied approach across its thirty-one tracks; the intro actually occurs at the end of the album, and loops back into the outro, heard at the start (obviously). Its beats have turned up on releases by The Roots, Nas and Ghostface Killah, among others.

The album's success is all the more remarkable given that it was mostly recorded in hospital while the increasingly frail Dilla underwent treatment. Days after its release, he was dead from heart failure, having spent years with his auto-immune system crippled by lupus and an incurable blood disease. Fittingly, his Minimoog Voyager synth and MPC drum machine now sit in the Smithsonian's National Museum of African American History and Culture.

KOOL KEITH (1963)

—— OUT-THERE RAPPER

Dizzyingly talented, but seemingly incapable of – or uninterested in – harnessing his gifts for commercial ends, Kool Keith circles planet hip-hop with a highly erratic orbit. He's assumed a plethora of identities (of which Dr. Octagon is probably the best known) and costumes, and the warped grand-guignol concepts behind his albums take some digesting. Yet his prolific imagination and lyrical dexterity have influenced Eminem (who mentions him on 'Monster'), Kanye West and OutKast, to name but a few.

Keith co-founded the under-rated Ultramagnetic MC's, whose debut album *Critical Beatdown* (1988) was belatedly lauded as a hip-hop landmark, not least because of his own impressionistic, intricate wordplay and Cedric 'Ced-Gee' Miller's ground-breaking sampling.

Keith's Beefheartian imagination flexed fully for the first time on his solo debut *Dr. Octagonecologyst* (1996), a jazzy mash-up of porn, horror and sci-fi that introduced the character of a time-travelling serial-killer surgeon from Jupiter (Dr. Octagon). Keith's metaphor-rich lyrics incorporate deftly-turned internal rhymes and half rhymes, while their surreal associations have a unique, hallucinogenic logic of their own. With superlative contributions from turntablist DJ Qbert and producers Dan the Automator and KutMasta Kurt, the album is regarded as another milestone in the genre. But for follow-up *Sex Style* (1997), he abandoned Octagon for what he dubbed 'porncore'. Incorporating explicit raps and samples from porn movies, it distanced many fans of its predecessor.

Prodigy's sample of 'Critical Beatdown' and Keith's recruitment for their 'Diesel Power' track provided a lucrative acknowledgement of his impact, but his album *Black Elvis/Lost in Space* (1999) – the eponymous narrator a galaxy-hopping rock star – so confounded his label, Columbia, that they sat on it. Enraged, Keith produced horror-fest *First Come, First Served* (1999) to get some product out there. Its opening track saw Dr. Octagon abruptly killed off by new alter ego Dr. Dooom, a cannibalistic homicidal maniac. It has been mooted that this release was a conscious effort on Keith's part to alienate the cross-genre audience he'd won with *Dr. Octagonecologyst* – which had been fêted as an alternative rap classic – and return to street hip-hop.

Since that golden age, Kool Keith has seldom scaled such heights. But the one-off concept albums, a modestly received reunion with Ultramagnetic MC's and less inspiring revivals of Dr. Octagon and themes he's already explored shouldn't obscure his impact. There's just no arguing with his lyrical ingenuity and febrile imagination.

FELA KUTI (1938–1997)

—— AFROBEAT PIONEER AND REVOLUTIONARY

Few artists are authentic rebels – icons whose presence, let alone their music, is a threat to the establishment. Bob Marley, Peter Tosh and Víctor Jara all fit the bill and had their lives threatened – and in Jara's case, ended – for what they symbolized. Enter Fela Kuti.

Born into a privileged Yoruba family in Nigeria, Fela Anikulapo Ransome-Kuti enrolled at London's Trinity College of Music in 1958, playing trumpet in Soho's jazz hotspots at night, with an early incarnation of what would later become his band, Africa '70. By the time he returned home in 1963, he was blending jazz with the country's highlife music, later adding funkier Afrosoul leanings inspired by Sierra Leone's Geraldo Pino.

A trip to the USA brought Fela and Africa '70 into contact with the civil rights movement and the Black Panthers. Back in Nigeria, by the early 1970s he was promoting Afrocentrism and dishing out social critiques. His group became stars, with a string of bestsellers. Driven by drummer Tony Allen's defiantly African rhythms, call-and-response vocals and strident brass, and with a fervent Fela declaiming out front, their long shows were ecstatic and ritual-like. His songs addressed crippling poverty and Nigeria's corrupt military junta, making him an icon to the country's downtrodden poor. And an enemy to its rulers.

In 1974, police busted him twice in rapid succession at his communal compound/

studio, Kalakuta Republic, and Fela had declared the compound independent of the state in 1970. Later in 1974, it was attacked again by hundreds of police, with Fela and his companions imprisoned and badly beaten. *Kalakuta Show*'s sleeve depicts an attack on his home, while the acclaimed *Zombie* (1976) satirizes mindless military brutality. As the harassment escalated, so Fela's reputation as a folk hero grew (though he regularly berated his audience for not standing up to their oppressors). He relished the role, dubbing himself the 'Black President'. But in February 1977, more than 1,000 soldiers descended on his compound, razing it to the ground. Fela was nearly killed and his mother later died of her injuries.

Unbowed, Fela continued to rail against injustice – and paid the price. In 1984, he was jailed on a trumped-up charge of smuggling, though widespread international condemnation saw his sentence curtailed. He took on Nigeria's Obasanjo military regime on 'Army Arrangement' (1985), and on *Beasts of No Nation* (1989) blasted the right-wing conservatism of Ronald Reagan, Margaret Thatcher and P.W. Botha (a trio of horned vampires on the cover). His final years were dogged with hit-and-miss concerts and ill health (exacerbated, no doubt, by all those beatings), but his death from an AIDS-related illness brought a million mourners onto the streets of Lagos – as befitted a people's president.

ARTHUR LEE (1945-2006)

—— WEST COAST WUNDERKIND

Love were the 1960s' great might-have-beens, artistic peers of The Byrds and The Doors but never achieving their due success. That was partly down to the refusal of their leader, Arthur Lee, to tour or jump through promotional hoops; he even nixed Love's invite to the pivotal Monterey Pop Festival in 1967. Then again, if not for Lee, we wouldn't be talking about Love at all.

In 1965, Lee's folk-rock group The Grass Roots metamorphosed into Love. Working Los Angeles clubs around Sunset Strip, the racially mixed group evolved into a formidable live act. Adding a tougher R&B edge to a ringing, Byrdsian sound, they became the first band to sign to the fabled Elektra Records. But it was only on their second album, *Da Capo* (1966), that Lee's songwriting talents flowered, on the blistering proto-punk '7 and 7 Is' (a US no.33, their highest placing), jazz-inflected 'Stephanie Knows Who' and the baroque pop of 'She Comes in Colors'.

By 1967, drugs (heroin, acid) and in-fighting were fracturing the band, making that year's *Forever Changes* – Lee's masterpiece – all the more remarkable. Love were never hippies and the album offers a caustic perspective on flower-power optimism, incorporating complex arrangements, shifting time signatures and a sonic palette ranging from garage punk to show tunes. The surface sparkle of 'Live and Let Live' and 'The Red Telephone' belied their brooding lyrics. Lee was reportedly fixated on mortality at the time, stating that the album was intended as 'my last words to this life... It's like death in there'. Its best-known track, the gorgeous, mariachi-inflected 'Alone Again Or', was actually written by bandmate Bryan MacLean, whose compositions Lee largely sidelined. Unaccountably, the set only scraped to no.152 Stateside, although in Britain it rose to a respectable no.24.

Post-*Forever Changes*, the band rapidly splintered. Lee resurrected Love with replacement musicians, but never approached such heights again. In the 1970s, he more or less abandoned music, becoming more isolated and erratic and occasionally serving time in jail; in the mid-1990s, he was imprisoned for the alleged negligent discharge of a gun (the charge was overturned in 2001). Thankfully, the following year he was on tour again, fronting a new Love (featuring members of Baby Lemonade) to play *Forever Changes* in its entirety. He enjoyed two more years of belated acclaim before the leukaemia that was eventually to take his life brought his performance days to an end.

LYDIA LUNCH (1959)

—— NO-NONSENSE NO WAVE ICON

Lydia Lunch first made her name in New York in 1976 with Teenage Jesus and the Jerks, purveyors of brief, aggressive songs ('aural terror', in her own words) and curt, confrontational gigs. A key figure on the city's 'no wave' scene – offering a loud and arty counterpoint to the more accessible new wave – this prolific artist has gone on to collaborate with a broad range of avant-garde, leftfield artists, building an unsettling, often sexually themed back catalogue while also establishing herself as a writer.

Trenchantly anti-commercial (and anti-imperialist-America), the vitriol of her lyrics found a complementary soundtrack in collaborations with a host of fellow noiseniks, including Einstürzende Neubauten (on 'Thirsty Animal' (1982)), Swans' Michael Gira (on 1984's spoken-word *Hard Rock*) and Sonic Youth on their *Death Valley '69* EP (1985). The music website *Consequence of Sound* classed the Sonic Youth title track as one of the scariest songs in rock. In the 1980s, Lunch also released a split EP with Australia's inflammatory punk outfit The Birthday Party, with whom she shared a common interest in violent and sexual subject matter. She was to reconvene with the group's Rowland S. Howard, most notably on the eerie blues mini LP *Shotgun Wedding* (1991).

But Lunch is too smart to be restricted to one noisy niche. Her solo debut *Queen of Siam* (1980) had jazzy overtones, while her subsequent band, 8 Eyed Spy, embraced funk. Having formed her own label and production company, Widowspeak, in 1985, she opened her long spoken-word career with the EP *The Uncensored Lydia Lunch*. She'd begun working with film-makers not long after her musical debut, playing a dominatrix in *Black Box* (1978) by Scott B and Beth B, and also appearing in two outré 8mm movies by underground film-maker Richard Kern. She shed a little light on where all that anger and borderline insanity came from with her semi-fictional autobiography *Paradoxia* (1997), which detailed her mental-health issues and substance abuse. Her other publications take in comix, photography, indictments of censorship and a typically provocative cookbook.

If there's a thread that ties all that work together, it's Lunch's devotion to personal expression in all forms; her many collaborations, and itinerant sensibilities, bear witness to this. First and foremost, she is an artist-provocateur, an iconoclast toppling pop's icons from their pedestals and railing against conformity. All of which makes her a commercial non-starter, but Lunch has never played that game, seeing herself instead as part of a long tradition of radical artists and performers. 'It's not about popular culture, it's not about fucking record sales,' she raged in 2008. 'It's about doing and saying what needs to be said.'

"IF YOU'RE DOING IT FOR THE MONEY, YOU'RE NOT DOING ART. YOU'RE DOING COMMERCE."

MOONDOG (1916-1999)

—— STREET ARTIST

For thirty years, a sightless, six-foot-tall bearded man occupied Manhattan street corners for up to eight hours a day, dressed in robes and a Viking helmet and carrying a spear, playing music on home-made instruments. The man born Louis Thomas Hardin Jr was blinded as a teenager by a dynamite cap, but honed his childhood musical talent at schools for the blind and learned to compose in braille. He arrived in New York in his late twenties and took to the pavements to perform. A helpful cabinet-maker built his self-designed instruments, including the 'oo' (a twenty-five-stringed triangular harp), 'utsu' (a keyboard with pentatonic tuning) and 'trimba' (a percussion box).

Initially Moondog began performing near Carnegie Hall, rapidly attracting the praise of musicians in the New York Philharmonic and receiving invitations to rehearsals. He'd long since become disillusioned with the Christianity in which he'd been raised, veering instead towards Norse myth; when one too many passers-by had compared his appearance to Jesus Christ, he adopted his signature Viking guise.

And he composed. He'd sit on the stairs at Birdland Jazz Club, accompanying the jazz playing inside. He absorbed the sounds of the city, from traffic noise and sirens to pigeons fluttering overhead; one composition was entitled 'Duet: Queen Elizabeth Whistle and Bamboo Pipe'. Moondog's devotion to counterpoint never left him, but his direct contact with Native American musicians as a child also had a lasting impression. 'I'm into swing,' he once noted. 'I get that from the American Indians like the Sioux, the Arapahoe and the Apache.' 'Snaketime Rhythms' was named for his characteristic shifting, hissing beat that also graces 'Moondog's Symphony' (both recorded c.1949).

By the 1950s, Moondog was known and praised by the likes of Leonard Bernstein (who wrote a poem for him), Charles Mingus and Charlie Parker, and gigged with Beat writers Allen Ginsberg and William Burroughs. He was lauded as a countercultural icon in the 1960s, his song 'All is Loneliness' covered by Janis Joplin. Minimalists Philip Glass and Steve Reich were both admirers, while CBS financed two orchestrated albums of his music, including a ballet suite he'd composed for choreographer Martha Graham and the beguiling 'Lament 1: Bird's Lament' – sampled by Mr. Scruff for 1999's 'Get a Move On'.

In the 1970s, Moondog was taken in by a family in Germany, giving him the luxury of space and comfort to compose – which he did, prolifically. And in 1983 he was asked back to New York to conduct the Brooklyn Philharmonic Orchestra for a half-hour set of his work. Rarely has an artist succeeded so utterly on his own terms.

NICO (1938–1988)

—— BLEAK BEAUTY

By the time she sang with The Velvet Underground on their seismic 1967 debut album, Nico – born Christa Päffgen – already had a profile as an actress (she appears in Federico Fellini's *La Dolce Vita*) and fashion model. But her vocals on that album (for which she received co-billing) presented her as a new and unique presence in rock, her low voice crooning sweetly on 'I'll Be Your Mirror', more sinisterly on 'Femme Fatale', and stridently on the epic 'All Tomorrow's Parties'. She seemed aloof (or resigned), as if emotion could no longer touch her.

Following her departure from the band, she hit the New York coffeehouse circuit, supported by a range of musicians including Jackson Browne and The VU's John Cale, Lou Reed and Sterling Morrison. She set out her own artistic stall with 1967's *Chelsea Girl* (the title a nod to an Andy Warhol movie, *Chelsea Girls*, in which she'd appeared). Her austere tones cut through the folksy arrangements, to particularly mesmerizing effect on Bob Dylan's 'I'll Keep It With Mine' and Browne's 'These Days'. Despite the autumnal chamber-pop setting (which irked her), Nico invests the songs with a striking degree of melancholy.

Encouraged by then-lover Jim Morrison of The Doors, she began writing her own songs, dyeing her hair red and wearing black in an attempt to distance herself from her past ('She figured all her beauty had brought her was grief,' mused John Cale). The bleak sound world of *The Marble Index* (1968) offered a stark contrast to her debut; producer Cale found it closer to modern classical music than anything in rock 'n' roll. The album also introduced Nico's harmonium, which was to provide her signature sound; by chance, its unconventional tunings forced Cale to find atypical accompanying instruments (viola, pipes, glockenspiel), resulting in the album's singular soundscape. Unsurprisingly, the hollow intoning and Gothic settings found only a small audience, but the desolate beauty of this and follow-up *Desertshore* (1970), a meditation on loss and mental instability, has endured.

Artists as diverse as Elliott Smith and Siouxsie Sioux have cited her as an inspiration; Patti Smith befriended her. Her nihilism endeared her to punks, while her guitar-free sonic palette paved the way for the bleaker end of post-punk; Joy Division's *Closer* (1980) seems a troubled son of *The Marble Index*. In her most gripping work, Nico is an avant-garde chanteuse for the lost and desperate, a dispassionate guide to the darkest corners of the human soul.

YOKO ONO (1933)

—— SO MUCH MORE THAN MRS LENNON

After a concert for his mother's eightieth birthday, Sean Lennon was asked what inspired his mother's ongoing creativity. 'She seeks out volatility,' he replied. And she's certainly experienced more than most.

Ono was an established artist by the mid-1960s, but her own career was rather sidelined by her headline-grabbing relationship with Beatle John Lennon. Classically trained as a child, she had gone on to work with avant-garde composers LaMonte Young and John Cage, but only made her first recordings with Lennon in the late 1960s. Those lack coherence, but 1970s' improvisation-friendly *Yoko Ono/ Plastic Ono Band* featured startling material – witness the scarifying 'Why', on which her vocal volleys trade off against Lennon's wild guitar. *Approximately Infinite Universe* (1973) offers confrontational but measured feminism ('What a Bastard the World Is'). Ono's 1970s albums saw her steadfastly stake out her ground, assimilating the

parameters of pop while remaining faithful to her artistic instincts. Free jazz, tape loops, found sounds, funk, hard rock and pianism all fed her fire.

Lennon's shocking murder prompted *Season of Glass* (1981). Understandably harrowing, its cover is a shot of his bloodied glasses, while gunshots precede the angular 'No, No, No', though there are moments of tender beauty too ('Nobody Sees Me Like You Do', 'Toyboat'). She would eventually begin to receive her dues from younger generations, notably Hole and Sonic Youth (she collaborated with the latter's founders on *YokoKimThursto*n in 2012). By the 1990s, her influence was implicit in the riot grrrl movement, while on the cathartic *Rising* (1995) she paired her unfettered vocals to the hard-rock/funk backing of IMA, featuring son Sean.

After her husband's murder, Ono took control of his estate and artistic legacy, while also continuing Imagine Peace, a

PEOPLE DON'T WALK OUT OF MY SHOWS ANY MORE. THEY EVEN SEEM TO ENJOY IT. IT WORRIES ME. IS IT ALL RIGHT THAT PEOPLE ARE STARTING TO UNDERSTAND WHAT I'M DOING?

series of strategies that the two had dreamt up (from billboard posters to newspaper adverts and a tower of light inaugurated in Iceland in 2007) to promote peace. Her stature now unquestionable, she was asked to curate the 2013 Meltdown arts festival on London's South Bank, recruiting Savages, Peaches and The Stooges, among others.

Ono's strong sense of self has sustained her through extraordinarily demanding times, from facing racist insults, to having her art questioned and being blamed for breaking up the biggest band of all time. Endearingly, that indomitability is paired with quiet humour – the title of 2007's remix set, *Yes, I'm a Witch*, a throwback to the time when she was a tabloid target. 'It's the rebel in me at work,' she has said of that sly title. 'But if I was not a rebel, I would have been squashed [a] long time ago.'

PEACHES (1966)

—— ELECTRO SHOCKER

Performance artist. Fuck-you feminist. Staunch defender of fringe sexualities. Opera singer. Electro-punk star. Peaches is all of these and more.

Her solo debut, *Fancypants Hoodlum*, arrived in 1995 under her real name, Merrill Nisker, but it would be five years until its follow-up. In the interim, she toured with Elastica, performed with sometime flatmate Feist, and moved to Berlin, where she soaked up theatre, cabaret, burlesque, hip-hop and rock. Crucially, she also purchased a Roland MC-505 synth ('I realized that with this machine, I could be every instrument I wanted to be').

In 2000, she emerged triumphantly from battles with thyroid cancer and the end of a relationship to produce *The Teaches of Peaches*, a ribald and provocative electronic party set including her signature hit 'Fuck the Pain Away'. For good measure, the cover featured a close-up of her crotch in hot pants. She swiftly became an underground club icon, although the unapologetic sexual explicitness of her lyrics saw her banned by some TV stations.

It wasn't just the words, though. An audacious exhibitionist, Peaches would take to the stage in hot pants, bra and wearing a dildo, or swamped in a cluster of fake breasts, or inside an 11ft model phallus. But much of that was a way of challenging gender stereotypes, and questioning why standards are different for female and male performers. She tackled traditional gender roles with *Fatherfucker* (2003) – she's bearded on the sleeve – and upped the ante to tackle politics on 2006's *Impeach My Bush* (for the cover she sports a sequin-adorned burqa).

Gleefully blending genres, she brought hip-hop to the party on *I Feel Cream* (2009), collaborating with fellow Canadian Chilly Gonzalez (her former bandmate in The Shit), Simian Mobile Disco and Soulwax, among others. She made an accomplished crossover to the stage in 2010 with her take on a British musical staple, *Peaches Christ Superstar*, in which, accompanied only by pianist Gonzalez, she delivered a measured and powerful performance that surprised critics. In 2012, in Berlin, she performed the (conventionally male) lead in Monteverdi's opera *L'Orfeo*, while 2013 saw her perform Yoko Ono's *Cut Piece* (1964), at the artist's request, for London's Meltdown festival.

Maybe her message is getting out there. The University of Toronto includes her in its Queer Studies curriculum, while her high-profile champions include Björk, Christina Aguilera (she appears on the her 'My Girls') and Karl Lagerfeld, for whom her songs were catwalk staples.

Now in her fifties, Peaches has ageism lined up in her sights. Twenty years on from her breakthrough, she's far from finished.

LEE 'SCRATCH' PERRY (1936)

—— THE MIGHTY UPSETTER

Born Rainford Hugh Perry (the nickname 'Scratch' came from an early single, 'Chicken Scratch'), he learned production skills under Clement 'Sir Coxsone' Dodd at Studio One in Kingston, Jamaica. Frustrated by a lack of recognition, though, he set up his own Upsetter Records and had his first hit, in 1968, with pioneering reggae single 'People Funny Boy'.

With his studio band The Upsetters, Perry played a pivotal role in defining and expanding reggae over the following decade. Inspired by King Tubby, his excursions into dub found him treating the studio mixing console as an instrument itself, manipulating the faders and employing heavy reverb to morph existing tracks into something new and strange. He also mentored Bob Marley in the early 1970s, overseeing the first two releases by The Wailers, although Marley's departure for Island Records – taking two members of The Upsetters with him to join The Wailers – infuriated him.

At his Black Ark studio in Kingston, Perry devised a bewildering range of production techniques that left the competition standing, including super-precise overdubbing and innovative effects. How effective his more esoteric actions were (burying tapes, spraying them with bodily fluids and alcohol, or blowing ganja fumes onto them) is less certain. By the late 1970s, artists as diverse as The Clash and Paul McCartney were seeking 'Scratch' out,

and he was producing hits of the calibre of Junior Murvin's 'Police & Thieves'. By the late 1970s, though, his creative streak was slowing; under mysterious circumstances – said to be by Perry's own hand, although possibly a simple electrical fault – Black Ark was destroyed in a fire in 1983. There were rumours of substance abuse and increasingly unstable behaviour. Likely in the throes of a breakdown, Perry moved first to London and then Switzerland, duly regaining his focus (arguably helped by his decision to quit alcohol and cannabis).

Aided by collaborations with the likes of Neil Fraser (aka the Mad Professor) and Adrian Sherwood, Perry's output (and its quality) escalated again. The Beastie Boys recruited him for *Hello Nasty*'s 'Dr. Lee, PhD' in 1998, while 2002's *Jamaican E.T.* won him a Grammy. Ten years later, he was awarded the Jamaican Order of Distinction. The destruction of his Swiss Blue Ark studio (definitely an accident this time) hasn't appreciably slowed his momentum, and this unclassifiable genius continues to tour, notably to mark the fortieth anniversary of his landmark *Super Ape* album.

Don't let the stream-of-consciousness spiel and double-take outfits fool you: the man poet Linton Kwesi Johnson dubbed 'the Salvador Dalí of Reggae' is a one-of-a-kind genius.

" I AM A PRINCE AND THE
MUSIC IS THE KING. "

ÉDITH PIAF (1915-1963)

—— 'THE LITTLE SPARROW'

Fêted both in her native France and internationally, this diminutive chanteuse also developed a cult following among LGBT communities and the French working class. The way she used her talent to transcend the manifold tragedies in her life remains an inspiration to all those who live outside the mainstream.

She was born in Paris (as Édith Giovanna Gassion), though probably not on the pavement of the Rue de Belleville, as one myth has it. Her unstable home life saw her sent to her paternal grandmother, who ran a brothel in Normandy. Whisked away by her father in 1929 she performed as a street singer with her half-sister, Simone Berteaut. Even then, the passion of her voice marked her out: full-throated, with a rapid vibrato, it proved the perfect vehicle for the highly emotional French *chanson*.

The 1930s saw her keep company with lowlifes, bearing a daughter (who died, aged two) when she was seventeen, and nearly being shot by a pimp boyfriend. Salvation came in the form of cabaret owner Louis Leplée, who tutored her in stage presence, gave her the simple black dress that became a trademark and dubbed her '*La Môme Piaf*' ('The Little Sparrow'). When Leplée was murdered, Piaf's underworld associations threatened her reputation, but a new mentor, Raymond Asso, stepped in. He rechristened her Édith Piaf and created a repertoire based on her hard-knock life, in partnership with Marguerite Monnot. By the late 1930s, Piaf was notching up hits including 'Mon légionnaire' and 'C'est lui que mon coeur a choisi'.

Despite the German occupation in World War II, her profile blossomed, with regular gigs in nightclubs (and brothels) that afforded her a luxury apartment in a desirable *arrondissement*. In 1947, she released 'La vie en rose', her signature song of enduring hope. Post-war, she helped promote artists such as Charles Aznavour

and Argentine folk singer Atahualpa Yupanqui, by touring with them. In another tragic twist, however, her life's love, one-time world boxing champion Marcel Cerdan, died in a plane crash in 1949; devastated, Piaf took solace in alcohol and other substances. 'Hymne à l'amour' became her poignant tribute.

Despite an initially cool reception, she eventually won over Stateside audiences, playing Carnegie Hall twice in the late 1950s and making multiple appearances on *The Ed Sullivan Show*. She enjoyed a huge international hit in 1959 with 'Milord', penned by then-lover Georges Moustaki, and the following year recorded what became her stirringly defiant epitaph, 'Non, je ne regrette rien'.

She lived only three more years. Health complications had arisen from three serious car crashes in the 1950s; long-term alcohol abuse took its toll too. In 1960, she collapsed mid-performance at New York's Waldorf Astoria, vomiting blood. Two years later, during the last in a string of legendary performances in the Paris Olympia music hall dating back to 1955, the frail, petite star could barely stand, yet miraculously her vocal power remained undiminished.

Piaf passed away in 1963. Her chequered past saw her denied a funeral mass by the Archbishop of Paris, but thousands of her fans followed her coffin, bringing the Paris streets to a standstill.

> ❝ EVERY DAMN THING
> YOU DO IN THIS LIFE,
> YOU PAY FOR. ❞

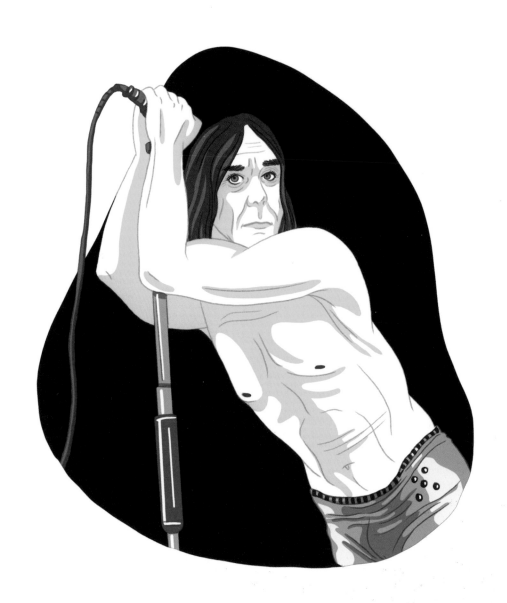

IGGY POP (1947)

—— GODFATHER OF PUNK

As frontman with The Stooges, Iggy Pop pioneered punk before the fact, the band's primal attack a sparse backdrop for his unhinged physical performances and audience-baiting taunts (The Doors' Jim Morrison was an influence). *The Stooges* (1969), *Fun House* (1970) and *Raw Power* (1973) crackled with malevolent riffs and visceral energy, topped with Iggy's street poetry, but with heroin and hedonism muddying the waters, they were commercial non-starters. In a famous televised gig in 1970, Iggy smeared himself with peanut butter and mince while standing on the audience's hands – all good clean/ dirty fun; by the mid-1970s, he was locked in a narcotic freefall, rolling on broken glass onstage and OD'ing.

David Bowie remained an admirer, though, seeking Pop out at his nadir and taking him on his *Station to Station* tour. In 1976, the two relocated to Berlin, where they shared an apartment and set about tentatively overcoming their respective demons. In a stunning return to form, Pop released his two greatest solo albums the following year, with Bowie credited as both producer and writer. *The Idiot* is decadent electronica that anticipates post-punk, while *Lust for Life* is his masterstroke, supremely focused from the euphoric title track and 'Success' to the brooding 'The Passenger'. Of course, Pop was never just a dumb-ass addict. While his feral presence on-stage put young punks to shame, his lyrics were concise and drily witty (witness 'I'm Bored' from 1979's *New Values*).

The following decade brought hits with 'Real Wild Child (Wild One)' (UK no.10) and 'Candy' (US no.28). *Brick by Brick* (1990) gave him his first gold-certified LP Stateside, followed three years later by another strong set, *America Caesar*; by now, his influence was being heard in the new wave of grunge acts emerging from the States. By 2003, he'd reunited with original Stooges Ron and Scott Asheton for four tracks on the well-received *Skull King*, and with bassist Mike Watt they toured to adoring crowds.

Pop's career has taken him in less likely directions, too. Like Jim Morrison (again), for a rock 'n' roll screamer he could be a surprisingly effective crooner. His jazzy 2009 set *Préliminaires* found the Ig covering standards 'Les feuilles mortes' and 'How Insensitive' alongside the spoken-word 'A Machine for Loving', the lyrics drawn from Michel Houellebecq's novel *The Possibility of an Island*.

He declared *Post Pop Depression* (2016) – a strong, ruminative set with Joshe Homme – his last album, but contrarily followed it with the off-piste *Free* three years later. Having so nearly become a martyr for rock 'n' roll, Iggy Pop has gone on to become its greatest living embodiment.

SIXTO 'SUGAR MAN' RODRIGUEZ (1942)

—— THE ULTIMATE COMEBACK KID

Few returns from obscurity have been as unexpected or triumphant as that of Mexican-American Sixto Diaz Rodriguez. Two albums in, his career stalled; the rumour circulating was that he had killed himself. The truth was far stranger.

His debut set, *Cold Fact* (1970), married socially aware, politically charged lyrics to a folk-rock/psychedelic setting with neatly structured arrangements. There's a trace of Dylan in his affectingly worn vocals. Melancholy lead track 'Sugar Man' mulls over the appeal of drugs in hard times and gave him his alias, while 'This Is Not a Song, It's an Outburst: Or, the Establishment Blues' dissected the ills of a damaged society. But despite the musical landscape in those turbulent times – Marvin Gaye's *What's Going On* would be a huge hit the following year – and Rodriguez's good looks, long jet-black hair and omnipresent sunglasses, it bombed. So did follow-up *Coming From Reality* (1971). Rodriguez slipped off the radar – in the USA, at least – becoming a construction worker in his native Detroit (though he still went around with a guitar on his back).

But in Australia, the Sydney DJ Holger Brockman began playing 'Sugar Man', leading to a rush on imported US copies of *Cold Fact* and highly successful rereleases of his two albums. In 1979, he was invited to play fifteen low-key gigs there. Meanwhile, white South Africans rebelling against their country's policy of apartheid – but largely isolated from the outside world – also took *Cold Fact*'s political messages to their hearts, bought half a million copies, turning its songs into anthems. The government banned it, even arranging for copies of the album destined for radio stations to be scratched. But demand for the album only went up and bootlegs supplemented the shortfall. Rodriguez became an anti-establishment Elvis.

In 1998, a handful of hardcore South African fans painstakingly tracked Rodriguez down to his modest home and invited him to tour in their home country, where he was rapturously received. ('We made love to your music,' one soldier told him. 'We made war to your music.') *Cold Fact* went platinum there, and five times platinum in Australia. By now, other musicians had picked up on him: Nas sampled 'Sugar Man' on 2001's *Stillmatic*, while David Holmes made it the first track on a 2002 compilation he curated. By 2012, Rodriguez was touring widely, while that year's *Searching for Sugar Man* documentary recounted his unlikely story, winning an Oscar and – *very* belatedly – showing the USA what it had missed.

Once a song is released, it becomes public property. That Rodriguez's social commentary inspired listeners thousands of miles away, and played a part in revolutionary social change without his knowledge, is stirring testimony to that.

ARTHUR RUSSELL (1951-1992)

—— CALLING OUT OF CONTEXT

Prolific but unheralded during his lifetime, Charles Arthur Russell's genre-blending music has since won an appreciative following. Devendra Banhart and LCD Soundsystem are among his admirers, while Kanye West sampled his track 'Answers Me' on '30 Hours'. Russell frequently reworked or abandoned his compositions, and this, coupled with his polymorphous output, may have hampered him in establishing an audience at the time.

Born in Oskaloosa, Iowa, Russell learned to play cello and piano before moving to San Francisco, California, in the late 1960s, where he studied Buddhism and north Indian classical music and collaborated with Allen Ginsberg. Buddhism became one of Russell's core influences, informing his fluid combination of genres and a tendency to see compositions as in flow rather than finite. It's there in the numerology he used when naming songs and bands, the references to the living world in his lyrics, and the gentleness that pervades his music.

After moving to New York, Russell became musical director of an avant-garde downtown arts space known as the Kitchen, associating with the likes of Steve Reich, Glenn Branca, John Cage and Rhys Chatham. Soon, he expanded the venue's minimalist agenda to include new wave acts (Talking Heads – whom he almost joined – and Jonathan Richman's Modern Lovers), while contributing to rock project The Flying Hearts, which at various stages included ex-Modern Lover Ernie Brooks and the Heads' David Byrne.

An encounter with DJ Nicky Siano introduced Russell to the nascent disco scene. Siano funded his innovative underground hit 'Kiss Me Again' (1978) under the pseudonym Dinosaur, the first disco tune released on Sire Records, featuring an uncredited David Byrne on guitar. Russell flexed his funkier side under the moniker Loose Joints with releases such as 'Is It All Over My Face' (1980) – which garnered a proto-house remix from the Paradise Garage's DJ Larry Levan – and 'Go Bang' (as Dinosaur L). Two years later, *24 24 Music* offered art-disco explorations (the title refers to the rhythm shifting after every twenty-four bars). He dubbed such pop-oriented releases 'Buddhist Bubblegum', a conduit for spreading messages of hope, humour and compassion. Elsewhere, his sparse classical set *Tower of Meaning* (1983), written for a production of Euripides' *Medea*, nods to minimalist masters such as Cage, Morton Feldman and LaMonte Young.

World of Echo (1986) – the only solo album Russell completed – is an intimate work in which his vocals and cello blend to mesmerizing effect. It's a mark of his versatility that the irresistible dance track 'Let's Go Swimming' is also from 1986 – tragically, the year that he was diagnosed as HIV positive.

RYUICHI SAKAMOTO (1952)

—— A QUIET STORM

Sakamoto has carved out one of the most diverse and influential CVs in contemporary music, embracing the classical rigour of Bach and 'sound colour' (his term) of Debussy, with cutting-edge electronica and avant-garde experimentalism.

As part of adventurous techno-pop trio Yellow Magic Orchestra (partly conceived as a pastiche of Western perceptions of orientalism), Sakamoto became a pop star in Japan, though their music made ripples further afield too. Afrika Bambaataa sampled YMO's 'Firecracker' on the *Death Mix* EP, and they were namechecked as influences by techno icons such as Derrick May and Kevin Saunderson; Sakamoto's 1983 solo single 'Riot in Lagos' anticipates the uneasy ambience of artists such as Aphex Twin and Boards of Canada. The same year, Sakamoto marked YMO's split with his first soundtrack, for *Merry Christmas, Mr. Lawrence*; its beguiling theme tune 'Forbidden Colours', sung by David Sylvian, was a hit. Although an untried actor, Sakamoto also appeared in the movie.

His score for Bernardo Bertolucci's *The Last Emperor* (1987) was a majestic collaboration with David Byrne and Cong Su, deservedly awarded an Oscar. His self-dubbed 'outernationalist' approach saw Sakamoto embrace cross-border musical pollination; he worked with reggae drummer Sly Dunbar, Brian Wilson and Senegal's Youssou N'Dour on 1989's *Beauty*, while

1993 soundtrack *Little Buddha* melded chamber orchestra, traditional Indian music and electronica. He offered intimate reworked Antônio Carlos Jobim's bossa nova classics on *Morelenbaum 2/Sakamoto: Casa* (2001), with cellist Jaques Morelenbaum and his vocalist wife Paula, both of whom had worked closely with Jobim. Sakamoto himself played his first instrument, the piano, which he returned to on 2002's *Vrioon* (with electronica artist Alva Noto). Like all original artists, Sakamoto knows the value of outside input: 'I like collaborating with people who have something I don't have – a skill, an idea... I need inspiration and triggers.'

The solo set *Playing the Piano* (2009) reinterpreted Sakamoto's past work while explicating his debt to French Impressionist composers such as Ravel, Debussy and Satie. Having survived a battle with throat cancer in 2014, he produced the minimalist soundtrack for *The Revenant* (with Noto and The National's Bryce Dessner). *async* (2017), his first solo work following his recovery, is a sparse set that seems to serve as a reflective contemplation of sound and mortality.

Joyous innovation paired with respect for tradition. Restless experimentalism married to pop melody. For forty years, Ryuichi Sakamoto has been one of the most intriguing and original presences in contemporary music.

THERE IS NOTHING MORE IMPORTANT TO ME THAN WRITING A GOOD SONG OR POEM... THAT'S WHAT I'M ADDICTED TO, THAT'S WHAT I CAN'T DO WITHOUT.

GIL SCOTT-HERON (1949–2011)

—— PROTO HIP-HOP POET

At his masterly best, Scott-Heron was an articulate and witty protest poet, an impassioned spokesperson for society's cast-outs, and an incisive commentator on his turbulent times. His voice is there in the equally articulate rage of Public Enemy and Kendrick Lamar, to name but two of his successors, while he's been sampled by hip-hop luminaries such as Kanye West, Drake and Common.

His debut album, *Small Talk at 125th and Lenox* (1970), references Malcolm X, Nina Simone and Pharoah Sanders, among other black icons, over a minimalist backing of three percussionists. 'The Revolution Will Not Be Televised' turned a Black Power slogan into a stinging commentary on TV consumerism and the marginalization of African-Americans. The track re-emerged in fleshed-out, funkier form on his second LP, soul-jazz classic *Pieces of a Man* (1971) – its bass, drums and rap effectively a hip-hop template – and as the B-side of the single 'Home Is Where the Hatred Is', a poignant account of a drug addict's listless existence. Elsewhere, 'Lady Day and John Coltrane' paid uplifting tribute to two black musical legends – and music itself as a sanctuary from life's hardships – while 'I Think I'll Call it Morning' displayed his gift for capturing the beauty in the everyday.

Scott-Heron had suffered racist abuse during his schooldays in Jackson, Tennessee (where he also discovered the work of inspirational poet Langston Hughes) and saw urban decay first-hand growing up in the Bronx. Those experiences informed his unflinchingly direct lyrics, which address the marginalization of black lives. Regular collaborators Brian Jackson (flute, piano, arrangements) and Robert Gordon (bassist) provided a danceable, jazzy bedrock to Scott-Heron's messages, even on 'The Bottle', a study of alcoholism that hit no.15 on the US R&B chart. Its parent album, *Winter in America* (1974), mapped the social deprivation endemic to many in Black America and took President Nixon to task on 'H2Ogate Blues'. 'Johannesburg' (1975) was a trenchant attack on apartheid South Africa, set to a shuffling disco beat; 'Angel Dust' (1978) offered a harder, funkier musical attack, while ' "B" Movie' lampooned President Reagan and his neo-con acolytes (a subject he returned to on 1984's 'Re-Ron').

By the 1990s, Scott-Heron's output had dwindled markedly, partly owing to the substance abuse that now dogged him (particularly tragic, as he'd once railed against the debilitating effect of drugs), but also as a result of writer's block. Thankfully, he found form again for what would be his valedictory release, the acclaimed and autobiographical *I'm New Here* (2010), before he passed away the following year.

THE SLITS (1976-1982; 2005-2010)

—— ATYPICAL GIRLS

Who best embodied the spirit of punk? The Sex Pistols, Damned and Clash were actually proficient musicians. But The Slits were musical non-starters *and* women to boot...

In the mid-1970s, the earliest members of the band were moving in the same circles as the nascent Pistols and Clash. After their debut gig in London supporting the latter in March 1977, the band reconfigured around singer Ari Up (Arianna Forster, then barely into her mid-teens), Palmolive (Paloma Romero) and Viv Albertine; the last two had played with Sid Vicious and Keith Levene (later of The Clash and Public Image Ltd) in Flowers of Romance. Joined by Tessa Pollitt, the ragamuffin quartet – all bird's-nest manes, fishnets and jumble-sale buys (Ari defiantly wore her knickers on the outside) – gave short shrift to more conventional female precedents in rock, from The Runaways to Suzi Quatro, or the thrusting aggression of male rockers. Instead, they looked to outspoken mavericks such as Yoko Ono.

The Slits attracted sexist catcalls and flying beer glasses from crowds when they supported The Clash on tour in '77, with Ari a gleefully provocative presence up front, but their debut LP *Cut* (1979) was the perfect riposte. (By then, future Banshees drummer Budgie had replaced Palmolive, who joined post-punk group The Raincoats – another game-changing all-female outfit and one of Kurt Cobain's favourite bands.) An essential release, its songs were dissonant but spacious; dub and reggae were prime influences. 'There's something feminine in the fluidity of dub,' observed Albertine, whose scratchy guitar was another signature feature. Taken from the album, the satirical 'Typical Girls', backed with a twitchy take on 'I Heard It Through the Grapevine', became their biggest UK 'hit' at no.60. Its provocative cover pictured three semi-naked Slits covered in mud.

A terrific cover of 'Man Next Door', originally by reggae artist John Holt, was released in 1980, and their second album, *Return of the Giant Slits,* appeared the following year (by which time Ari's trademark dreadlock pile was well established). But the band's momentum was faltering and they split in 1982. A reunion, heralded by the EP *Revenge of the Killer Slits* (2006), was rapturously welcomed, though only Ari and Tessa remained from the original line-up; with the singer's death in 2010, the band folded.

The Slits euphorically rejected male-oriented rock. There's a giddy freedom and sparseness to their best work, which – crucially – prioritizes rhythm (bass and drums) over guitar and vocals. Their unfettered deconstruction of rock has left a long legacy, taking in riot grrrl bands, Björk, Warpaint, Sonic Youth, The Cure and many, many more.

MARK E SMITH (1957–2018)

—— THE FALL GUY

Mark Edward Smith quit school at sixteen, becoming a shipping clerk at Salford Docks, though he completed an 'A' Level in English Literature at evening classes. A wildly inventive, well-read writer, Smith counted George Orwell, Kurt Vonnegut and HP Lovecraft among his literary favourites. He was at the near-mythic Sex Pistols gig at Manchester's Lesser Free Trade Hall in June 1976, and was inspired enough to form The Fall (named after an Albert Camus novel) the following year. By mid-1979, Smith was the only original member left; scabrous when the mood took him, he would see off some sixty-six Fall members during the band's career ('If it's me and yer granny on bongos, it's The Fall,' he once quipped). In John Peel's pithy paean to the band – 'They are always different, they are always the same' – the singer was the sole axis of continuity.

It wasn't just Smith's famous vocal sneer that marked out The Fall. Across thirty-one studio albums, his vivid and free-ranging imagination engaged with Nazi Germany ('Various Times', 'Garden'), and exorcism ('Spectre vs. Rector'), put the boot into nostalgia ('Glam-Racket') and took surreal snapshots from everyday life ('The Container Drivers') – or 'the horror of the normal', in his own words. None of which got in the way of The Fall delivering a string of exceptional, often bizarrely catchy singles. And those song titles! Like Morrissey at his peak, Smith's wordplay provoked and intrigued.

The Fall could be a potent, angular guitar band, but also summon up the eerily hypnotic 'Telephone Thing' (Smith believed his phone was being tapped), produced by electronic music twosome Coldcut, and just occasionally ('Bill is Dead', 'Edinburgh Man') even sound benign. They excelled as a covers band, too – witness their unlikely take on Sister Sledge's 'Lost in Music' and the snarling 'Mr Pharmacist' (by 1960s no-hit

wonders The Other Half), which became a concert staple. Repetition remained a key compositional aid in Smith's toolbox, something he shared with two of his core influences, The Velvet Underground and Can. He paid tribute to the latter's former lead singer on 'I am Damo Suzuki'.

Occasionally, The Fall flirted with the mainstream. *The Frenz Experiment* (1988) was their first UK Top 20 album and they cracked the Top 10 with *The Infotainment Scan* (1993), while their cover of R. Dean Taylor's 'There's a Ghost in My House' made UK no.30. But Smith's spiky personality made the band inherently unstable (perhaps he liked it that way) and likely limited the

possibility of greater commercial success. Former wife Brix Smith dubbed him a dictator; in 1998, three-fifths of the band quit on the spot after an on-stage scuffle.

A committed drinker and some-time drug user (classic early singles 'Fiery Jack' and 'Totally Wired' reference amphetamines), Smith's health became parlous in his later years, exacerbated by accidents and broken bones. By 2017, he was performing from a wheelchair. His death the following year, from kidney and lung cancer, closed the door on one of music's most uncompromising and prolific outsider icons.

TES

PANDER

LEVITATE

PATTI SMITH (1946)

─── ROCK 'N' ROLL POET

Smith broke through as part of New York's fledgling punk movement in the mid-1970s, but her uncategorizable artistic scope was never contained within those narrow parameters. While drawing on older bohemian traditions and Symbolist poetry as well as rock, she defined her own genre, an androgynous icon who succeeded on her own terms, through talent, intellect and uncompromising vision. Down the decades, however infrequent her recordings, Smith has remained steadfastly true to poetry, the spoken word and her own early influences.

In 1967, Patti Lee Smith gravitated to the Manhattan arts scene from New Jersey, rooming with future photography icon Robert Mapplethorpe (a period memorably reflected in her 2010 memoir *Just Kids*). By the early 1970s she had become a respected performance poet, channelling the visionary spirit of poets such as Arthur Rimbaud in her incantatory recitals. She began working with guitarist/rock critic Lenny Kaye, and

in 1974 recorded her debut single 'Hey Joe' – featuring Television's guitarist Tom Verlaine – backed by the incendiary 'Piss Factory'. The following year, Smith delivered what remains her most famous album, *Horses*; the cover portrait, by Mapplethorpe, presents her as intriguingly androgynous. From its atheistic opening declaration to the sexual realignment of the protagonist, her audacious remaking of Van Morrison's 'Gloria' was pure punk in spirit. (Sexual dualism is an enduring theme within her work.) The album as a whole was a richly diverse statement of intent, highlighted by her freeform lyrics, compelling chant-like deliveries (Allen Ginsberg and the Beat writers were an influence) and a supple performance from her band. It won her France's Académie Charles-Cros Grand Prix du Disque Award.

Easter (1978) gave her a hit single in the Bruce Springsteen co-write 'Because the Night', but also contained the controversial 'Rock 'n' Roll Nigger', Smith's attempt to

> ** I'VE EMBRACED ROCK 'N' ROLL BECAUSE IT ENCOMPASSES ALL THE THINGS I'M INTERESTED IN: POETRY, REVOLUTION, SEXUALITY, POLITICAL ACTIVISM. **

reassign that taboo term to denote anyone outside the accepted norm. After the following year's *Wave*, though, she largely abandoned music to raise a family with MC5 founder Fred 'Sonic' Smith in Detroit (the two collaborated on 1988's *Dream of Life*, featuring the rousing 'People Have the Power'). Only with his death from a heart attack did she fully engage with her solo career once more, returning with the respected *Gone Again* (1996), a measured reflection on mortality and loss, and touring with Bob Dylan – who had been a prime influence on her work. On his behalf, she went to accept the Nobel Prize for Literature in Sweden in 2016, giving a flawed but heartfelt performance of Dylan's 'A Hard Rain's A Gonna Fall', one of her late husband's favourite songs. *Peace and Noise* (1997) reunited her with Kaye and drummer Jay Dee Daugherty of the original Patti Smith Group and spawned the Grammy-nominated '1959'. *Gung Ho* (2000), a return to fierier form, gave Smith another Grammy nomination for 'Glitter in Their Eyes'.

In recognition of her achievement, she received Sweden's coveted Polar Prize in 2011, the organizers noting that 'Patti Smith has demonstrated how much rock 'n' roll there is in poetry and how much poetry there is in rock 'n' roll'.

KARLHEINZ STOCKHAUSEN (1928-2007)

—— ELECTRONIC PROVOCATEUR

Like many avant-garde pioneers, Stockhausen was a polarizing figure, many finding his innovations too extreme for the ear. Yet this adherent of serialism, pioneer of electronic music and all-round sonic adventurer had a deep impact on artists from Miles Davis to Kraftwerk, Björk and The Beatles (you can find him on the cover of *Sgt. Pepper*).

The genesis of that impact can be traced back to Stockhausen's tenure at the electronic music studio of the Northwest German Broadcasting Company in Cologne, beginning in 1953. Initially, he experimented with *musique concrète*, but, finding it limiting, focused instead on generating *elektronische musik*. In the mid-1950s, he composed *Gesang der Jünglinge* ('Song of the Children'), in which a choirboy's vocal tones are matched with electronic equivalents. Stockhausen applied serialist principles to both acoustic and electronic pitch, duration, timbre and dynamics in the piece. *Gruppen* (1957) utilized three orchestras, 'panning' between them and creating a tripartite conversation. For *Kontakte* (1960) – one of the earliest pieces to combine electronica with live percussion – he applied rigorous spectral analysis of the acoustic instruments to devise equivalent electronic timbres. *Hymnen* (1967) is a head-turning collage made from recordings of national anthems, synthesized sounds and snippets from short-wave radio broadcasts.

Such extremes were never destined for a mass audience. But Stockhausen's ideas influenced popular culture in myriad ways, not least in how he set aside convention and introduced a liberating attitude towards making music – or, indeed, to what 'music' was. One piece from his monumental operatic cycle *Licht* was written for four members of a string quartet, each placed in an airborne helicopter; the sound of the blades made its own contribution. Jean-Michel Jarre studied with him, as did Can's Holger Czukay and Irmin Schmidt. Miles Davis had a cassette tape of *Hymnen* in his car, adapting Stockhausen's collage-like approach, overdubs and tape manipulation for his album *On the Corner* (1972), while The Beatles' avant-garde 'Revolution 9' may have been inspired by the same work. Björk lauded his a cappella *Stimmung* (1968) for 'using the voice as a sound and exploring the nuances of it in a microscopic way'. But he wasn't revered by everyone.

Once dubbed the 'papa of techno', Stockhausen nevertheless dismissed Aphex Twin's music, advising him to listen to *Gesang der Jünglinge*, 'then he would stop with all these post-African repetitions and would look for changing tempi and changing rhythms'. In response, Aphex Twin suggested Stockhausen hear his own 'Digeridoo', 'then he'd stop making abstract, random patterns you can't dance to'.

SUN RA (1914–1993)

—— AFROFUTURIST SCI-FI SPACE PHILOSOPHER

As Herman Poole 'Sonny' Blount, in the late 1940s he'd recorded with R&B artist Wynonie Harris and served as pianist/arranger to Fletcher Henderson. But in the early 1950s came a dramatic about-face: Blount embraced mysticism, declared himself an alien from Saturn, renamed himself Sun Ra, and christened his band the Arkestra. They adopted robes and ornate headpieces that both looked back to ancient Egypt and forward to a sci-fi future.

The Arkestra were largely a hard-bop outfit in the mid-1950s, becoming increasingly percussive and more impressionistic in their approach as the decade progressed. Ra's next stylistic shift – allowing group and solo improvisation based on moods that he dictated – birthed the style for which he is best known, and which predates the free-jazz excursions of John Coltrane, Ornette Coleman and Eric Dolphy. By the mid-1960s, Ra was winning plaudits from the likes of Thelonious Monk and Dizzy Gillespie. He became one of the earliest jazz musicians to adopt electronic keyboards and naturally gravitated towards synthesizers in due course. Other innovations included getting his musicians to double up on instruments and the employment of two bassists (again, he was a jazz pioneer in incorporating the electric bass). He became a counterculture icon of

sorts, the Arkestra touring with the Grateful Dead in 1968 and Ra appearing on *Rolling Stone*'s cover the following year. *Space is the Place* (1973) – made to tie in with the eponymous out-there sci-fi movie – was both popular and experimental, the title track a heady blend of funk, Duke Ellington and Afrofuturism. At a time when black rights and identity was a burning topic, he made explicit jazz's origins in Africa.

Ra's prolific composition could result in one new piece a day – and a huge, untidy back catalogue. (Jazz aficionado Gilles Peterson has suggested that Ra's self-pressed records, with their hand-drawn covers, anticipated the DIY ethic of punk.) He opened up unprecedented directions in jazz, while keeping earlier traditions within his compass. Pharoah Sanders was a protégé, while George Clinton's Parliament/Funkadelic and Earth Wind and Fire picked up on many of his themes for their visuals. And in 2016, the themes of space and old Egypt informed Solange's sets for her *A Seat at the Table* tour (at some venues, the Arkestra's current incarnation supported her).

Sun Ra didn't just play free jazz, he embodied free expression and the right – indeed, the *necessity*, if you're serious about your art – to go further out. Or, in his own words, 'The possible has already been done.'

TOM WAITS (1949)

—— THE MAN WITH THE GOLDEN CROAK

'The music I listened to as a teenager was old people music,' Tom Waits reflected in 2004. 'I was suspicious of anyone new and young.' Out of step with most of his contemporaries in the early 1970s (Randy Newman being a notable exception), he drew on Tin Pan Alley traditions, vintage jazz and blues, and Beat writers. Album by album, Waits honed the stage persona of a particular kind of American outsider, the kind of lowlife you might find in an Edward Hopper painting or Charles Bukowski novel. Through them, he explored the frailties and beauties of the human condition.

Folky debut *Closing Time* (1973) featured wistful early-hours vignettes ('Ol' 55', later covered by the Eagles, was to provide a lucrative royalty stream). *The Heart of Saturday Night* (1974) was an intimate, jazzy set – largely piano ballads – through which Waits' signature bohemian boozehound character took shape, while *Nighthawks at the Diner* (1975) was a snapshot of his stage show, including his engaging between-song banter and tall stories. By now the self-mythologizing was in full flow, and Waits was actively cultivating the poverty-riddled, alcohol-fuelled lifestyle he sang of in his songs. His barfly-poet persona and gravelly vocals were fully formed on the well-received *Small Change* (1976), featuring the classic 'Tom Traubert's Blues' (later a UK Top 10 hit for Rod Stewart), which referenced 'Waltzing Matilda'. But by *Blue Valentine*

(1978) and *Heartattack and Vine* (1980), Waits was in danger of becoming a self-parody.

With the clattering *Swordfishtrombones* (1983), he audaciously broke new ground. Avant-garde US composer Harry Partch was a key influence in Waits' use of home-made instruments (aka his 'junkyard orchestra'), but a greater one was his marriage to Kathleen Brennan, who helped him escape his artistic rut and would become his prime collaborator. Guttural blues and the lurch of Brecht and Weill's art songs were somewhere in the mix too, as well as on follow-up *Rain Dogs* (1985), which featured scrap-metal percussion, car radios and Keith Richards (on 'Big Black Mariah'). Waits' more sentimental side emerged in 'Downtown Train', another hit for Stewart.

The apocalyptic *Bone Machine* (1992) earned him a Grammy, while the ghost of 1930s German cabaret re-emerged on the Faustian *The Black Rider* (1993), the music for a darkly humorous play created by writer William Burroughs and avant-garde director Robert Wilson. *Mule Variations* (1999) displayed a bluesier (as in Captain Beefheart) sound palette but was overall a more compassionate and warmer affair. He's created many such sound worlds – not exactly antiquated, but not of today's world either. 'Going back in time to locate something you can't find in the future,' in Tom Waits' own words.

SCOTT WALKER (1943-2019)

—— GOLDEN-VOICED OUTSIDER

As a 1960s heartthrob, Scott Walker experienced a bellyful of fame and fortune – and didn't much care for it. With The Walker Brothers (unrelated), a US trio also featuring John Maus and Gary Leeds, the man born Noel Scott Engel had enjoyed dizzying levels of adoration in the UK, from the band's arrival in February 1965 to their split in 1968. Stateside, he'd worked with session musician Jack Nitzsche – Phil Spector's right-hand man – and learned from him how to arrange the voluminous sound that dominated early Walkers releases. Reverb-heavy, thickly orchestrated and topped off with Scott's sublime baritone vocals, Walkers singles leapt up the British charts. 'The Sun Ain't Gonna Shine Any More' – a UK no.1 – is the best of the lot, although 'My Ship Is Coming In' and 'Make It Easy on Yourself' run it close for majestic melancholy. Obsessed fans reduced the trio's live appearances into brief but violent screamfests, though, deeply unsettling the reclusive star.

A Europhile by inclination, Scott had long admired the movies of Ingmar Bergman, Luchino Visconti and Federico Fellini. Now, his discovery of troubadour Jacques Brel paved the way for a new solo career incorporating Brel covers and Scott's own vignettes of outcasts and the surreality of the everyday. Skilfully and ambitiously orchestrated, his first three solo albums all made the UK Top 3. Unaccountably, the glorious fourth – entirely self-penned – bombed miserably and things shuddered to an ugly halt.

There followed a rush of albums by rote, peppered with lacklustre covers and movie themes, leaving Scott a depressed boozehound. A Walker Brothers reunion in the mid-1970s, however, unexpectedly led to a third, richly rewarding act in his career. One-off hit 'No Regrets' restored the Walkers to the British charts, but then their label – GTO – was forced to close. Contracted for one more album, Scott seized the moment,

producing four tracks flecked with atonality and free jazz; highlight 'The Electrician' offered a jarring snapshot from a South American torture cell. Improbably, it was released as a single – The Walker Brothers' last.

Henceforth, album releases were rare, the singer opting only to record an album when he felt he had something worth saying, and taking time out to study art. (In the meantime, early 1980s plaudits from fans such as Marc Almond and a Julian Cope-curated compilation reawakened interest in his classic late-1960s solo work.) Songs, as such, were abandoned for increasingly dark and frequently violent soundscapes addressing the primal nature of humanity, taking in subjects from 9/11 to Elvis Presley's stillborn brother (both in 'Jesse') and the execution of Benito Mussolini ('Clara'). 'Farmer in the City (Remembering Pasolini)' was a brooding, almost operatic vignette on the last day in the life of the Italian film-maker, sung in a tremulous tenor (Walker's voice had risen since his 1960s pomp). Sudden blocks of sound and dissonance replaced verse-chorus-solo; Scott's characteristic croon made way for yelps. If his muse demanded the sound of pork being punched ('Clara' again), clashing machetes ('Tar'), or drone-metal moans (the Sunn O))) collaboration 'Herod 2014'), so be it.

And with each painstakingly produced release, Scott Walker created a genre of his own.

"GOOD ART NEVER GOES ONE WAY."

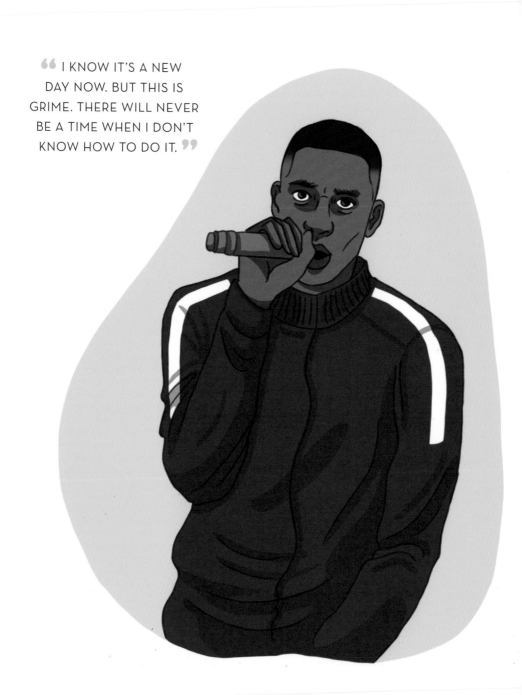

"I KNOW IT'S A NEW DAY NOW. BUT THIS IS GRIME. THERE WILL NEVER BE A TIME WHEN I DON'T KNOW HOW TO DO IT."

WILEY (1979)

—— GODFATHER OF GRIME

A pivotal figure in the rise of grime in the UK, Wiley has followed an unpredictable path that has seen him avoid (consciously or not) major mainstream success. But few have had a greater influence on modern British music.

A childhood affection for 1980s cartoon series *ThunderCats* saw Richard Kylea Cowie rename himself Wiley Kat, then Wiley. As part of the Pay As U Go Cartel, he scored a UK Top 20 hit in 2002 with 'Champagne Dance', but it was after they split that this east Londoner began evolving a distinctive new style – initially with the Roll Deep crew, which was variously to feature Dizzee Rascal, Skepta and Tinchy Stryder, all of whom Wiley later mentored. He began rapping in his own voice – rather than aping Stateside accents – about the city he knew. Promoted on radio station Rinse FM (then a pirate), his single 'Eskimo' (2002) became an underground hit. Rife with leftfield rhythms, a game-changing hollow bass sound and weird synths, and altogether odder, weirder and colder than the UK garage that had preceded it, it heralded the arrival of grime – though Wiley dubbed the sound 'eskibeat', comparing it to 'dark garage'.

He went on to become a proficient and prolific producer as well as a respected artist in his own right, alternating between his hardcore grime roots and mainstream, pop chart success. Solo debut album *Treddin' on Thin Ice* (2004) was an instant grime classic.

'Wearing My Rolex' was a 2008 UK no.2, while 2012 saw him score a no.1 with 'Heatwave' and a no.3 with the Skepta-featuring 'Can You Hear Me? (Ayayaya)'.

Wiley always prioritized community and collaboration. In 2004, he formed Eskibeat Recordings to support upcoming grime acts. He's never quite let go of (or transcended?) his roots, and remained living in the same neighbourhood even after his chart successes. During a dead time for grime – from around 2007 to 2013 – he stayed true to the genre, creating a string of mixtapes and underground hits along with three albums, all self-released or on independent hip-hop label Big Dada. He shows a Prince-like devotion to music-making, often heading straight back to the studio after a live gig; impatient to get his music heard, in 2010 he uploaded a couple of hundred songs for free.

True, he hasn't made it easy for himself, and admits that he panics at make-or-break moments. He infamously feuded with one-time bro' Dizzee Rascal, and blew out a Glastonbury Festival appearance in 2013, while a drug charge stymied his chances of US live dates. He has retired, then returned. But his impact on 21st-century British music is undeniable, a fact officially acknowledged by the MBE bestowed on him in 2018.

ROBERT WYATT (1945)

—— KEEPING THE RED FLAG FLYING

Often described as one of England's national treasures, Wyatt's actually a far more subversive presence – defiantly left-wing, pro-trade union and critical of imperialism in all its forms. None of which has stopped him from creating some of the most affecting pop music of his time.

In the late 1960s, he drummed with Canterbury's Soft Machine, instilling their prog-rock sensibilities with jazzy experimentalism, not least on his twenty-minute 'Moon in June' (1970). After quitting, he formed Matching Mole (the name a pun on 'Machine Molle', French for his former outfit's name), with whom he recorded the disarming love song 'O Caroline'. But his life turned upside down in June 1973, when he fell from a fourth-floor window at a party, breaking his back; he's been wheelchair-bound ever since.

Wyatt's first solo set, *Rock Bottom* (1974), proved to be a career high of poignant love songs that liberated Wyatt artistically; although no longer able to drum as he had before, he found new possibilities in his singing and songwriting. This staunchly anti-elitist singer has always loved pop as much as his cherished jazz, and his cover of The Monkees' 'I'm a Believer' resulted in a surprise hit that year. He performed the song on British TV staple *Top of the Pops*, although – in an unflattering vignette of the times – the show's producer had attempted to convince him (unsuccessfully) to swap his wheelchair for a chair, so as not to offend viewers' sensibilities.

From the mid-1970s on, Wyatt and his wife Alfie stepped up their political engagement, embracing the West's arch-enemy communism 'simply to try and find the common humanity we've all got', as he reflected in 2012. By the 1980s, he was covering the work of songwriters such as Cuba's Violeta Parra and Chile's Víctor Jara, while 1984 saw him contribute to *The Last Nightingale*, an album whose proceeds went to support the miners' strike in the UK. He also recorded the definitive rendition of Elvis Costello's anti-Falklands War 'Shipbuilding' (1982). *Old Rottenhat* (1985) offered a downbeat state-of-the-nation inventory, and by the mid-1990s Wyatt was experiencing something of a breakdown, but out of that crisis came *Shleep* (1997), one of his best, featuring contributions from Paul Weller and Brian Eno among others.

Gifted with what Ryuichi Sakamoto described as 'the saddest voice in the world', Wyatt has continued to attract collaborators as diverse as Hot Chip and Björk (on 2004's *Medúlla*). Something deeply humane resonates in that voice, and it's to be cherished.

FRANK ZAPPA (1940–1993)

—— HEAD MOTHER

Subversive, intellectual, scatological, acidly satirical and wildly prolific, Zappa created a body of work embracing multiple genres over a thirty-year career. His early influences included doowop, R&B, blues and avant-garde classical composers, notably Edgard Varèse and Igor Stravinsky; Zappa was already a serialist composer as a teenager.

His band The Mothers ('of Invention' was added at the insistence of their nervous label, MGM-Verve) started out as an R&B bar band, but debut set *Freak Out!* (1966) was a Dadaist explosion, lampooning US pop culture – and one of rock's first double albums. *Absolutely Free* (1967) and *We're Only in It for the Money* (1968, sporting a satire of The Beatles' *Sgt. Pepper* cover) rammed the point home.

Lumpy Gravy (1967) represents Zappa's first major orchestral work. The musicians were initially sceptical about his scores, and although he ultimately earned their respect, he always struggled to extract committed performances from classical musicians. The album's sound collages and Zappa's innovative audio editing marked him out even further. His considerable guitar skills also shone on *Hot Rats* (1969). Featuring fans' favourite 'Peaches en Regalia', and his first album after disbanding the original Mothers, it's often cited as Zappa's finest, an early example of jazz-rock fusion.

Perhaps because of regular touring, Zappa's commercial stock rose in the 1970s,

with *Over-Nite Sensation* (1973) going gold, and *Apostrophe (')* (1974) a no.10 hit – his highest chart placing. The breadth and depth of his talent as an orchestrator and improvisational guitarist played out across his 1970s releases, as he continued to collapse the boundary between high and low art, not least with provocative song titles such as 'Jewish Princess' and 'Titties and Beer'. The satirical 'Valley Girl', a duet with his daughter Moon Unit, provided a surprise transatlantic hit in 1982.

Zappa remained a trenchant critic of any system (be it communism, organized religion or the Parents Music Resource Center) that curtailed an individual's thought or expression. But defending free speech can be costly, as he discovered when he went to court over the Royal Albert Hall's refusal to allow him to perform the score for his movie *200 Motels* (1971) on the grounds of obscenity. He lost. In 1985, his fundamental rejection of censorship led him to testify before a Senate committee, while his artistic stature saw the Czech president Václav Havel nominate him as Special Ambassador to the West on Trade, Culture and Tourism. Unlike the US establishment, Havel was a fan.

Prostate cancer claimed Zappa in 1993, but the year also saw belated recognition of his status as a modern composer when Germany's Ensemble Modern performed his *Yellow Shark* suite. At last, the world was catching up with him.

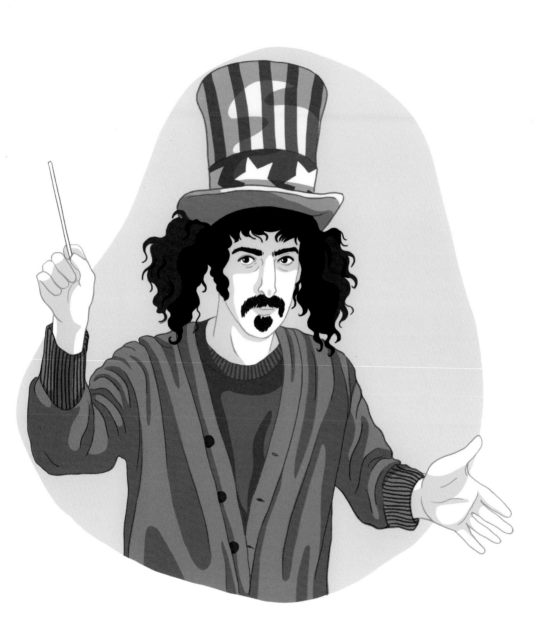

KEY WORKS

—

Laurie Anderson
Big Science (1982)
Mister Heartbreak (1984)
Strange Angels (1989)
The Ugly One with the Jewels (1995)
Homeland (2010)
Heart of a Dog (2015)
Landfall (2018)

Aphex Twin
Selected Ambient Works 85–92 (1992)
Surfing on Sine Waves (1993)
Digeridoo EP (1992)
On EP (1993)
Selected Ambient Works Vol. II (1994)
I Care Because You Do (1995)
Ventolin EP (1995)
Richard D. James Album (1996)
Come to Daddy EP (1997)
'Windowlicker' (1999)
Syro (2014)

Syd Barrett
'Arnold Layne' (1967)
'See Emily Play' (1967)
The Piper at the Gates of Dawn (1967)
The Madcap Laughs (1970)
Barrett (1970)

Kat Bjelland
Spanking Machine (1990)
To Mother EP (1990)
Fontanelle (1992)

Painkillers EP (1993)
With Katastrophy Wife:
All Kneel (2004)

Björk
With The Sugarcubes:
Life's Too Good (1988)
As a solo artist:
Debut (1993)
Post (1995)
Homogenic (1997)
Selmasongs (2000)
Vespertine (2001)
Medúlla (2004)
Volta (2007)
Biophilia (2011)
Vulnicura (2015)
Utopia (2017)

Lili Boulanger
Nocturne pour violon et piano (1911)
Faust et Hélène (1913)
Clairières dans le ciel (1913–14)
Psalm 130 (1914–17)
Vieille prière bouddhique (1914–17)
*D'un soir triste/D'un matin de
 printemps* (1917–18)
Pie Jesu (1918)

John Cage
Sonatas and Interludes (1946–48)
String Quartet in Four Parts (1950)
Music of Changes (1951)

4' 33" (1952)
Etudes Australes (1974–75)

Captain Beefheart

Safe as Milk (1967)
Strictly Personal (1968)
Trout Mask Replica (1969)
Lick My Decals Off, Baby (1970)
Clear Spot (1972)
Shiny Beast (Bat Chain Puller) (1978)
Doc at the Radar Station (1980)

Nick Cave

With The Birthday Party:
Prayers on Fire (1981)
Junkyard (1982)
With The Bad Seeds:
From Her To Eternity (1984)
The Firstborn is Dead (1985)
Kicking Against the Pricks (1986)
Tender Prey (1988)
The Good Son (1990)
Let Love In (1994)
The Boatman's Call (1997)
No More Shall We Part (2001)
Abattoir Blues/The Lyre of Orpheus (2004)
*The Assassination of Jesse James by the
 Coward Robert Ford* (2007; soundtrack)
Dig, Lazarus, Dig!!! (2008)
Skeleton Tree (2016)
Ghosteen (2019)
With Grinderman:
Grinderman (2007)

Grinderman 2 (2010)
As a novelist:
And the Ass Saw the Angel (1989)

Manu Chao

With Mano Negra:
Patchanka (1988)
Puta's Fever (1989)
Casa Babylon (1994)
As a solo artist:
Clandestino (1998)
Próxima Estación: Esperanza (2001)
Radio Bemba Sound System (2002)
Baionarena (2009)

Alex Chilton

With Big Star:
#1 Record (1972)
Radio City (1974)
Third/Sister Lovers (recorded 1974; released 1978)
As a solo artist:
Like Flies on Sherbert (1979)
Cubist Blues (1996)

Alice Coltrane

A Monastic Trio (1968)
Huntington Ashram Monastery (1969)
Ptah, the El Daoud (1970)
Journey in Satchidananda (1971)
World Galaxy (1972)
Reflection on Creation and Space (1973)
Eternity (1976)
Transcendence (1977)

Transfiguration (1978)

Translinear Light (2004)

World Spirituality Classics 1: The
 Ecstatic Music of Alice Coltrane
 Turiyasangitananda (2017; compilation)

Betty Davis

Betty Davis (1973)

They Say I'm Different (1974)

Nasty Gal (1975)

Sandy Denny

With Fairport Convention:

What We Did on Our Holidays (1969)

Unhalfbricking (1969)

Liege & Lief (1969)

With Fotheringay:

Fotheringay (1970)

As a solo artist:

The North Star Grassman and the Ravens (1971)

Sandy (1972)

Like an Old-Fashioned Waltz (1974)

Delia Derbyshire

Featured on:

Doctor Who (1963)

Standard Music Library (1969)

BBC Radiophonic Music (1971)

Electrosonic (1972)

Out of This World (1976)

BBC Radiophonic Workshop 21 (1979)

With White Noise:

An Electric Storm (1969)

Nick Drake

Five Leaves Left (1969)

Bryter Layter (1971)

Pink Moon (1972)

Brian Eno

With Roxy Music:

Roxy Music (1972)

For Your Pleasure (1973)

As a solo artist:

Here Come the Warm Jets (1974)

Taking Tiger Mountain (By Strategy) (1974)

Another Green World (1975)

Discreet Music (1975)

Before and After Science (1977)

Ambient 1: Music for Airports (1978)

Apollo: Atmospheres and Soundtracks (1983)

Thursday Afternoon (1985)

Nerve Net (1992)

January 07003: Bell Studies for the
 Clock of the Long Now (2003)

The Ship (2016)

Collaborations:

(No Pussyfooting) (1973, with Robert Fripp)

Evening Star (1975, with Robert Fripp)

Fourth World, Volume 1: Possible
 Musics (1980, with Jon Hassell)

My Life in the Bush of Ghosts (1981, with
 David Byrne)

The Pearl (1984, with Harold Budd)

Small Craft on a Milk Sea (2010, with
 Leo Abrahams and Jon Hopkins)

Roky Erickson

With The 13th Floor Elevators:

The Psychedelic Sounds of The
 13th Floor Elevators (1966)

Easter Everywhere (1967)

As a solo artist:

True Love Cast Out All Evil (2010)

Marianne Faithfull

Broken English (1979)

Strange Weather (1987)

Blazing Away (1990)

20th Century Blues (1996)

The Seven Deadly Sins (1998)

Vagabond Ways (1999)

Kissin' Time (2002)

Before the Poison (2004)

Give My Love to London (2014)

Negative Capability (2018)

Brigitte Fontaine

Brigitte Fontaine est... folle! (1968)

Comme à la radio (1969)

Brigitte Fontaine (1972)

Vous et Nous (1977)

Les Palaces (1997)

Kékéland (2001)

Rue Saint Louis en l'île (2004)

Serge Gainsbourg

No.2 (1959)

L'Étonnant Serge Gainsbourg (1961)

Anna (1967)

Initials B.B. (1968)

Histoire de Melody Nelson (1971)

Vu de l'extérieur (1973)

Aux armes et caetera (1979)

With Jane Birkin:

Jane Birkin/Serge Gainsbourg (1969)

Bobbie Gentry

Ode to Billie Joe (1967)

The Delta Sweete (1968)

Local Gentry (1968)

Touch 'Em with Love (1969)

Fancy (1970)

Patchwork (1971)

PJ Harvey

Dry (1992)

Rid of Me (1993)

To Bring You My Love (1995)

Stories From the City, Stories From the Sea (2000)

White Chalk (2007)

Let England Shake (2011)

Mark Hollis

With Talk Talk:

The Colour of Spring (1986)

'It's Getting Late in the Evening' (1986)

Spirit of Eden (1988)

Laughing Stock (1991)

As a solo artist:

Mark Hollis (1998)

J Dilla

Donuts (2006)

The Shining (2006; posthumous)

The Diary (2016; posthumous)

Kool Keith

Dr. Octagonecologyst (1996)

First Come, First Served (1999)

Black Elvis/Lost in Space (1999)

Diesel Truckers (2004)

Fela Kuti

Open & Close (1971)

Why Black Man Dey Suffer (1971)

Shakara (1972)

Gentleman (1973)

Before I Jump Like Monkey Give Me Banana (1975)

Expensive Shit (1975)

Ikoyi Blindness (1976)

Yellow Fever (1976)

Kalakuta Show (1976)

Zombie (1976)

No Agreement (1977)

Shuffering and Shmiling (1978)

Unknown Soldier (1979)

ITT (1980)

Music of Many Colours (1980)

Black President (1981)

Arthur Lee

Da Capo (1966)

Forever Changes (1967)

Four Sail (1969)

Lydia Lunch

Queen of Siam (1980)

13:13 (1982)

Honeymoon in Red (1987)

Oral Fixation (1988; spoken-word)

Drowning in Limbo (1989)

Paradoxia: A Predator's Diary (1997; book)

Smoke in the Shadows (2004)

With Rowland S. Howard:

Shotgun Wedding (1991)

With Cypress Grove:

A Fistful of Desert Blues (2014)

Moondog

Moondog on the Streets of New York EP (1953)

Moondog (1956)

More Moondog (1956)

Songs of Sense and Nonsense – Tell it Again (1957)

Moondog (1969)

Elpmas (1991)

Sax Pax for a Sax (1994)

Nico

Chelsea Girl (1967)

The Marble Index (1968)

Desertshore (1970)

The End... (1974)

Yoko Ono

Yoko Ono/Plastic Ono Band (1970)

Fly (1971)

Season of Glass (1981)

Yes, I'm a Witch (2007)

Between My Head and the Sky (2009)

Take Me to the Land of Hell (2013)

Peaches

The Teaches of Peaches (2000)

Fatherfucker (2003)

Impeach My Bush (2006)

I Feel Cream (2009)

Lee 'Scratch' Perry

As a producer:

Return of Django, The Upsetters (1969)

Soul Rebels, The Wailers (1970)

Soul Revolution, Bob Marley and The Wailers (1971)

Beat Down Babylon, Junior Byles (1972)

Rhythm Shower, The Upsetters (1973)

Upsetters 14 Dub Blackboard Jungle, The Upsetters (1973)

Super Ape, The Upsetters (1976)

War Ina Babylon, Max Romeo and The Upsetters (1976)

'Complete Control', The Clash (1977, with Micky Foote)

Heart of the Congos, The Congos (1977)

Police & Thieves, Junior Murvin (1977)

'Punky Reggae Party', Bob Marley (1977)

As a solo artist:

Cloak and Dagger (as 'Upsetter', 1973)

Roast Fish, Collie Weed & Corn Bread (1978)

Time Boom X De Devil Dead (1987)
Lord God Muzick (1991)
Dub Take the Voodoo Out of Reggae
 (1996, with Mad Professor)
Technomajikal (1997)
Jamaican E.T. (2002)
The Mighty Upsetter (2008)

Édith Piaf

'Les mômes de la cloche' (1936)
'Mon légionnaire' (1936)
'C'est lui que mon coeur a choisi' (1938)
'L'accordéoniste' (1940)
'La vie en rose' (1946)
'Les trois cloches' (1946)
'Mais qu'est-ce que j'ai?' (1947)
'Hymne à l'amour' (1950)
'Padam, padam...' (1951)
'Je t'ai dans la peau' (1952)
'La goualante du pauvre Jean' (1954)
'Sous le ciel de Paris' (1954)
'La foule' (1957)
'Mon manège à moi' (1958)
'Milord' (1959)
'Non, je ne regrette rien' (1960)
'Mon Dieu' (1960)
'L'homme de Berlin' (1963)
Édith Piaf at the Paris Olympia (1982,
 compilation of her performances
 at the venue)

Iggy Pop

With The Stooges:
The Stooges (1969)
Fun House (1970)
Raw Power (1973)
As a solo artist:
The Idiot (1977)

Lust for Life (1977)
New Values (1979)
Brick by Brick (1990)
American Caesar (1993)
Post Pop Depression (2016)

Sixto 'Sugar Man' Rodriguez

Cold Fact (1970)
Coming From Reality (1971)

Arthur Russell

Tower of Meaning (1983)
World of Echo (1986)

Ryuichi Sakamoto

With Yellow Magic Orchestra:
Yellow Magic Orchestra (1978)
Solid State Survivor (1979)
As a solo artist:
Thousand Knives of (1978)
B-2 Unit (1980)
Beauty (1989)
Heartbeat (1991)
Discord (1998)
Playing the Piano (2009)
async (2017)
Collaborations:
'Steel Cathedrals' (1985, with David Sylvian)
Morelenbaum²/Sakamoto: Casa
 (2001, with Jaques and Paula Morelenbaum)
Vrioon (2002, with Alva Noto)
Insen (2005, with Alva Noto)
Cendre (2007, with Christian Fennesz)
Soundtracks:
Merry Christmas, Mr. Lawrence (1983)
The Last Emperor (1987, with David Byrne
 and Cong Su)
The Sheltering Sky (1990)

Gil Scott-Heron

*Small Talk at 125th and Lenox (*1970)
Pieces of a Man (1971)
Winter in America (1974)
The First Minute of a New Day (1975)
From South Africa to South Carolina (1975)
It's Your World (1976)
Bridges (1977)
1980 (1980)
I'm New Here (2010)

The Slits

Cut (1979)

Mark E Smith

Bingo-Master's Break-Out! (EP, 1978)
Live at the Witch Trials (1979)
Grotesque (After the Gramme) (1980)
Slates (EP, 1981)
Hex Enduction Hour (1982)
Perverted by Language (1983)
*The Wonderful and Frightening
 World of The Fall* (1984)
This Nation's Saving Grace (1985)
The Frenz Experiment (1988)
Extricate (1990)
The Infotainment Scan (1993)
Levitate (1997)
The Marshall Suite (1999)
The Unutterable (2000)
*The Real New Fall LP (Formerly
 Country on the Click)* (2003)
Reformation Post TLC (2007)
Imperial Wax Solvent (2008)
Sub-Lingual Tablet (2015)

Patti Smith

'Hey Joe'/'Piss Factory' (1974)

Horses (1975)
Easter (1978)
Gone Again (1996)
Trampin' (2004)
Twelve (2007)
Banga (2012)

Karlheinz Stockhausen

Gesang der Jünglinge (1955–56)
Gruppen (1957)
Kontakte (1960)
Piano Pieces I–X (1952–61)
Momente (1964)
Telemusik (1966)
Hymnen (1967)
Stimmung (1968)
Mantra (1970)
Tierkreis (1975)
Licht (1977–2003)

Sun Ra

Jazz in Silhouette (1959)
The Magic City (1966)
Cosmic Tones for Mental Therapy
 (1967; recorded 1963)
Strange Strings (1967)
Atlantis (1969)
Space is the Place (both the 1972 soundtrack –
 which remained unreleased until 1993
 – and 1973 studio album of the same name)
Some Blues But Not the Kind That's Blue (1977)
Disco 3000 (1978)
Lanquidity (1978)
New Steps (1978)
Mayan Temples (1990)
Concert for the Comet Kohoutek (1993;
 recorded 1973)
I Roam the Cosmos (2015; recorded 1972)

Tom Waits

Closing Time (1973)

Small Change (1976)

Heartattack and Vine (1980)

Swordfishtrombones (1983)

Rain Dogs (1985)

Bone Machine (1992)

Mule Variations (1999)

Bad as Me (2011)

With Crystal Gayle:

One From the Heart (1982; soundtrack)

Scott Walker

With The Walker Brothers:

'The Sun Ain't Gonna Shine Any More' (1966)

'The Electrician' (1978)

As a solo artist:

Scott (1967)

Scott 2 (1968)

Scott 3 (1969)

Scott 4 (1969)

Tilt (1995)

The Drift (2006)

Bish Bosch (2012)

Soused (2014, with Sunn O))))

Wiley

Treddin' on Thin Ice (2004)

Playtime is Over (2007)

100% Publishing (2011)

Godfather (2017)

Robert Wyatt

The End of an Ear (1970)

Rock Bottom (1974)

'At Last I Am Free' (1980)

'Shipbuilding' (1982)

Dondestan (1991)

Shleep (1997)

Cuckooland (2003)

Comicopera (2007)

Frank Zappa

With The Mothers of Invention:

Freak Out! (1966)

Absolutely Free (1967)

We're Only in It for the Money (1968)

Uncle Meat (1969)

Burnt Weeny Sandwich (1970)

Weasels Ripped My Flesh (1970)

The Grand Wazoo (1972)

Over-Nite Sensation (1973)

Roxy & Elsewhere (1974)

One Size Fits All (1975)

As a solo artist:

Lumpy Gravy (1967)

Hot Rats (1969)

Chunga's Revenge (1970)

Apostrophe (') (1974)

Sheik Yerbouti (1979)

Shut Up 'n Play Yer Guitar (1981)

You Are What You Is (1981)

Jazz from Hell (1986)

Guitar (1988)

Broadway the Hard Way (1988)

The Yellow Shark (1993)

Läther (1996; posthumous)

INDEX

Robert Dimery is a writer, editor and music expert who has worked on Tony Wilson's *24 Hour Party People*, *Breaking Into Heaven: The Rise and Fall of the Stone Roses*, plus countless other popular music publications. He was general editor of *1001 Albums You Must Hear Before You Die* and *1001 Songs You Must Hear Before You Die* and has worked for a variety of magazines, including *Time Out London* and *Vogue*.

Kristelle Rodeia is a freelance illustrator based in Paris. After studying Plastic Arts and Graphic Design, she is now a full time illustrator working in a mixture of pen, ink and digital drawings. Previous clients include *Stylist*, Veneta Bottega and *Erratum*.

Also in the Series:

CULT ARTISTS
CULT FILMMAKERS
CULT WRITERS

Brimming with creative inspiration, how-to projects and useful information to enrich your everyday life, Quarto Knows is a favourite destination for those pursuing their interests and passions. Visit our site and dig deeper with our books into your area of interest: Quarto Creates, Quarto Cooks, Quarto Homes, Quarto Lives, Quarto Drives, Quarto Explores, Quarto Gifts, or Quarto Kids.

First published in 2020 by White Lion Publishing, an imprint of The Quarto Group.
The Old Brewery, 6 Blundell Street,
London, N7 9BH,
United Kingdom
T (0)20 7700 6700
www.QuartoKnows.com

A catalogue record for this book is available from the British Library.

ISBN 978 0 71125 062 8
Ebook ISBN 978 0 71125 063 5

10 9 8 7 6 5 4 3 2 1

Design by Paileen Currie
Illustrations by Kristelle Rodeia

Printed in China